The Zen of Creative Painting

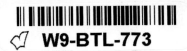

The Zen of Creative Painting

An Elegant Design for Revealing Your Muse

Jeanne Carbonetti

WATSON-GUPTILL PUBLICATIONS/NEW YORK

To my mother and father,
whose creative act of love gave me life.

Front cover
Tuscan Autumn (detail)
Watercolor on paper, 20 × 20" (51 × 51 cm), 1997.

Frontispiece
Christmas Birches
Watercolor on paper, 22 × 30" (56 × 76 cm), 1996.

Title page
Our Hill, Winter
Watercolor on paper, 22 × 30" (56 × 76 cm), 1996.

Contents page
The Gift
Watercolor on paper, 30 × 22" (76 × 56 cm), 1995.

Senior Acquisitions Editor, Candace Raney
Edited by Robbie Capp
Designed by Areta Buk
Graphic production by Ellen Greene
Text set in 11.5 Adobe Caslon

Library of Congress Cataloging-in-Publication Data
Carbonetti, Jeanne.
 The Zen of creative painting : an elegant design for
revealing your muse / Jeanne Carbonetti.
 p. cm.
 Includes index.
 ISBN 0-8230-5973-1
 1. Painting—Technique. 2. Painters—Psychology.
3. Self-perception. 4. Zen Buddhism. I. Title.
ND1473.C37 1998
750'.1'9—dc21 98-35575
 CIP

Printed in Hong Kong

First printing, 1998

3 4 5 6 7 8 9 / 06 05 04 03 02 01 00

ABOUT THE AUTHOR

Painter Jeanne Carbonetti, author of *The Tao of Watercolor,* the
first book in this series, instructs creative workshops and art
classes in her hometown, Chester, Vermont, where she owns
the Crow Hill Gallery and Art Center.

Acknowledgments

With great appreciation, I wish to credit all those who helped to birth this book: artists Judith Carbine, Fran Danforth, Harry Dayton, Carmen Fletcher, Janet Fredericks, Ann Kellogg, Rita Malone, John McNally, Janet Ponce, Meg Robinson, Zena Robinson, and Geraldine Stern; George Leisey, photographer, Henry Hammond, computer processor, and Claire Gerus, literary agent; Candace Raney, acquisition editor, Robbie Capp, book editor, Areta Buk, book designer; and my husband, Larry, for his help and support.

Thank you.

Jeanne Carbonetti
JAR OF ANEMONES
Watercolor on paper,
8 × 8" (20 × 20 cm), 1998.
Private collection, Vermont.

*The only thing that separates
us from Buddha is that the
Buddha doesn't find fault.*
Dennis Genpo Merzel

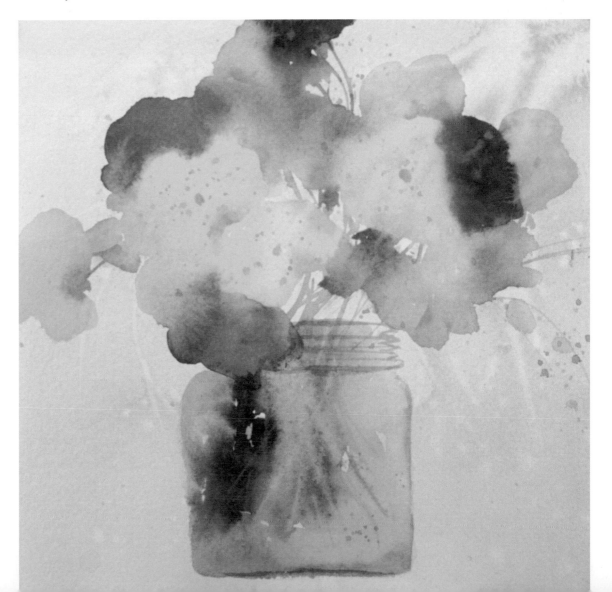

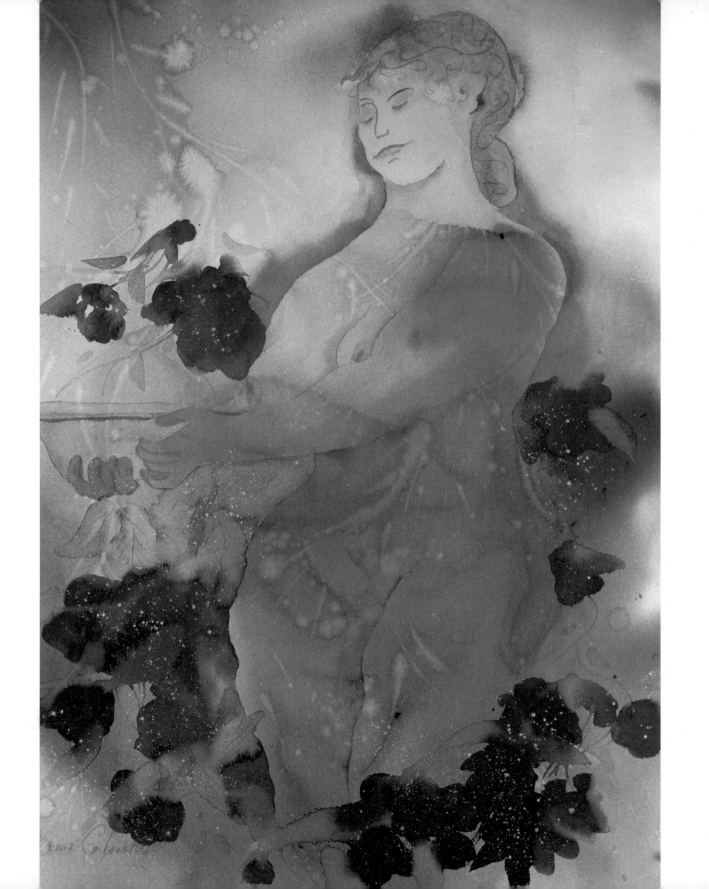

Table of Contents

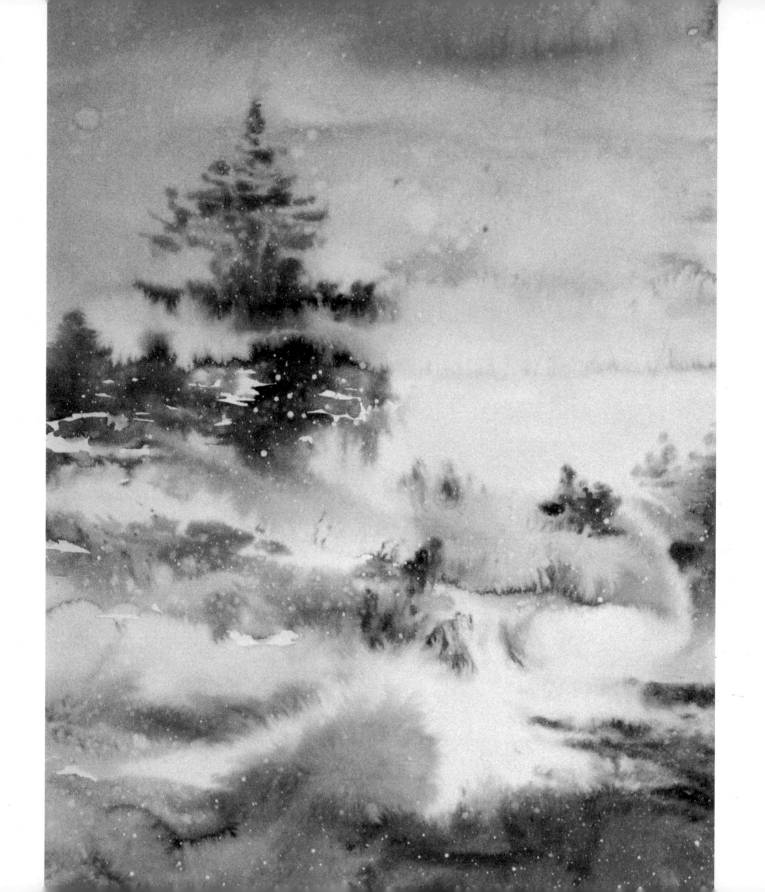

All of nature was called to a conference by the Great One. They were to decide if humankind should remain within the Sacred Cosmos Society. It was Sky, a very good mediator, who spoke first.

"As you know, the question is whether humankind is worth the trouble. On the one hand, humans do some good things, especially in science and sometimes in art. On the other hand, they often forget about the rest of us and our well-being. Since each of us has a special part to play within the great order, we must consider humankind's purpose. In short, do we really need humans?"

"No," said Sun, rising aggressively from his end of the table. "We don't need them at all. We did perfectly well for millions of years before they arrived. I surely have done my part! I've never forgotten to usher in each new day and provide the light the rest of you need. If you ask me, it's not logical to waste time on them."

Sun was known for putting up a good argument, and all were quite impressed.

"I tend to agree with Sun," said Earth. "Look at what I must put up with. They divide me into little pieces and sell me off to the highest bidder. They crowd and pollute me so, I can hardly breathe at times." Earth was pretty upset now. "And what's more, my name is *Earth*. Why do they call me 'dirt'?"

Then Rain spoke. "Let us think about our true purpose. As we each play a unique part in the universe and together balance one another, don't we alone make the whole? You, Sun, and you, sweet Earth, *you* have the powers of creation, so human beings can't claim that as their purpose."

"And *we* help with that creation," Wind puffed.

"That's right," said Rain, "and when need be, Wind and I can destroy as well."

"Yes" said Wind, all puffed up again, "so we have the powers of creation and destruction. We can do everything! We don't need humankind!"

It seemed that humans offered nothing special, and soon a chant rose up, "Humans are good for nothing, good for nothing."

"Except for one thing," said a clear voice on the other side of the table. It was Moon, whose strong yet quiet way made the others listen. "You are right, my friends, when you say that we are powerful and always fulfill our purpose in the great scheme. Yes, it is we who hold the secrets of Beauty and Truth. Yet with all our majesty, we do not have the power of the third secret. Only humans have that power. Only with them is the Triad complete." And in a still quieter voice Moon said, "They can love."

And all of nature sat in quiet wonder at the thought, for they knew Moon was right. And the Great One smiled.

Jeanne Carbonetti
HEAVEN AND EARTH
Watercolor on paper,
30 × 15" (76 × 38 cm), 1986.
Private collection, New York.

Preface:
The Meaning
of Zen

No one can see

who does not kindle

a light of his own.

Buddha

Jeanne Carbonetti
MYTH OF THE SACRED TRIANGLE
Watercolor, story, and collage on board,
60 × 60" (152 × 152 cm), 1987.
Collection of the artist.

*Be yourself:
purely,
simply,
outrageously,
completely.*

believe that the only way for an artist to grow in vision or in power, whatever his or her medium and ultimate goal may be, is to be oneself—purely, simply, outrageously, completely. Whether we are artists or scientists, craftsmen or tradesmen, philosophers or practitioners, we are all creators, and we each create best when we use our total self—blending body, mind, and spirit. Zen masters tell us that when we work from our hearts, we naturally arrive at this place of oneness; then our work is holy and an expression of the true self. It is the realm of the Muse.

But how do you find that Muse? When you secretly promise to seek yourself, the process will come easily, and soon your creations will flow without interruption. As Westerners, we tend to be very energetic in our pursuits. We think that if we just try harder, we'll stumble upon the formula that works for us, something that will take the terrible mystery out of our struggle to express.

But creativity *is* a mystery. That's the great secret to unearthing its treasures. For what you seek to explore and to fathom is really yourself. Why do you love that tree so much that you wish to paint it? Why does the curve of that pitcher mesmerize you, while the straight line of this one leaves you cold? Why do you feel connected to all you see?—or, if you feel adrift, where has part of you gone?

In Zen training, honoring the mystery that is you is accomplished by *allowing* yourself to be revealed, rather than by dictating your own direction. It's an intuitive approach rather than a logical one, meant to replace outward drive with inner authority. It is seeing yourself fully and trusting yourself implicitly.

As artists, we respect the mystery whenever we let our work speak to us, as we embrace a beloved child who presents a surprise to us, even if the child has a dirty face. We honor the mystery every time we start work not determined to *say* something, but with the desire to *ask* something, to discover rather than explain.

When you open yourself to the mystery, like artists in ancient times, you may see your work as prayer. But now your prayer is to your Muse, hidden in the shadows, waiting for you to be receptive enough to hear her voice. She is shy. She needs to be; she is not of this world.

I call the Muse "she" to represent that aspect of our nature that is receptive, rather than active. In each of us there resides that receptive female, along with the active male, and the spirit of the child—parts that must merge for creation to come to completion. That family of the self that you grow into is your Muse. As you reveal each part of yourself, you grow larger, always shedding a smaller view for a larger one. This is the big voice behind creative genius that comes from the sacred triangle of body, mind, and spirit. Akin to the myth in the Prologue,

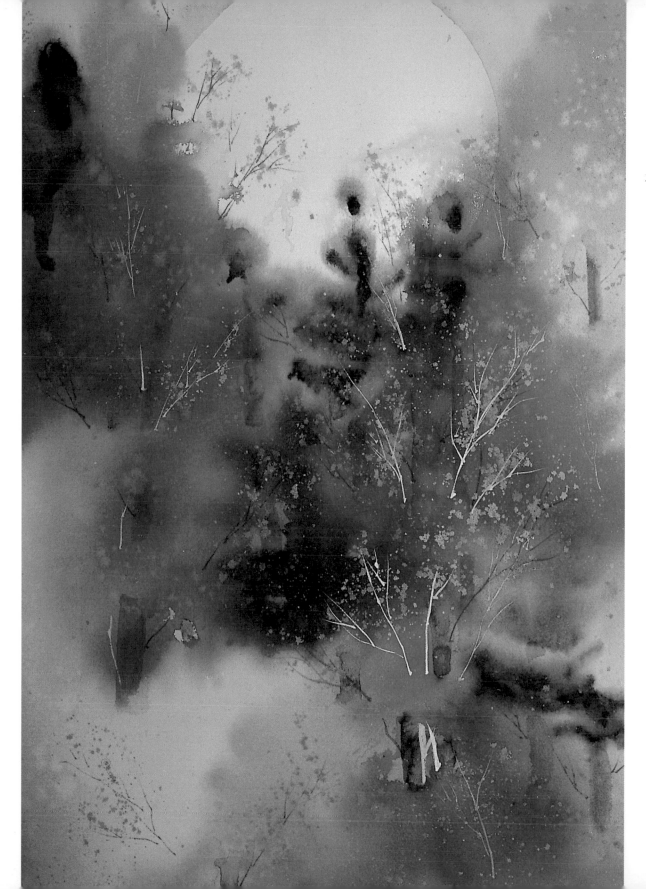

Jeanne Carbonetti
PIENZA PINES
Watercolor on paper,
28 × 22" (71 × 56 cm), 1997.
Collection of the artist.

And the end of all our
exploring will be to
arrive where we started
and know the place for
the first time.
T. S. Eliot

Until we accept the fact
that life itself
is founded in mystery,
we shall learn nothing.

Henry Miller

we learn to recognize the mother in us, whose essence is beauty, representing our earthly nature through the voice of the body; the father in us, whose essence is truth, speaking to us through the mind; and the child in us, whose essence is love, coming to us through the spirit found in the heart. When we reveal that oneness of body, mind, and spirit, we are one with our Muse.

An image comes to mind of King Arthur waiting quietly in his boat for the mists to part in Avalon. While others go by chatting, or hurriedly seeking to get somewhere, Arthur waits—and listens—and looks for signs. It is then that the veils between the worlds part, and the eternal is seen, hidden within the temporal. It is here that Arthur sees and hears his other side, the side of his true heart speaking. His Muse, his true self, is revealed, and Arthur becomes a master of Zen.

You can, too.

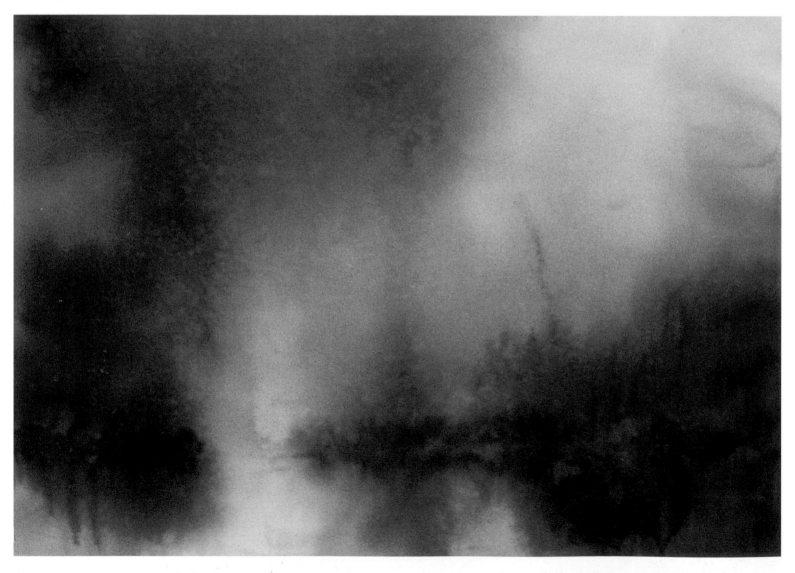

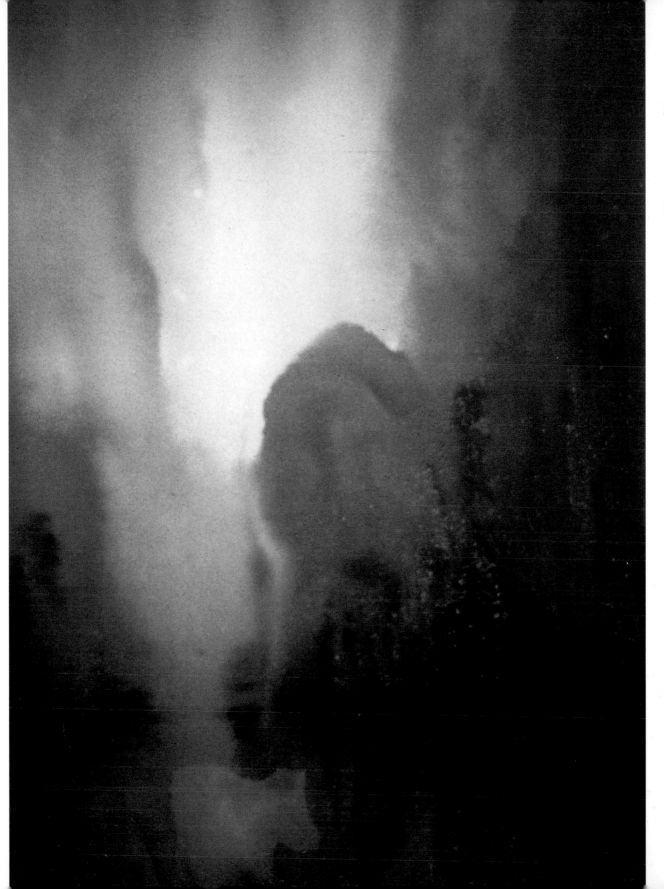

Jeanne Carbonetti
ENTRANCE TO
AVALON
Watercolor on paper,
30 × 22" (76 × 56 cm),
1987 . Private
collection, Vermont.

*The most beautiful
understanding in
the world is that of
the mysterious.*
Albert Einstein

15

Although I've written this book primarily for painters, even if your creativity lies in other realms, or if you're a beginner and don't consider yourself an artist at all as yet, I know that you are. There is creative power within you, for we all share the language of feeling, which is the realm of art.

As you move through this book, you'll learn how to release your Muse in four specific directions: creating mandalas, then works of landscape, still life, and figure art. Beginning with the ancient art of the mandala, you'll learn to make marks and then read them to discover hidden parts of yourself that will come alive to serve your art in all areas of creativity. Gradually, as more of you is revealed, you'll recognize and become one with your Muse.

Come and meet your true self. I promise you, you will be entranced.

Jeanne Carbonetti
Breath of Spring
Watercolor on paper,
22 × 30" (56 × 76 cm), 1988.
Private collection, New Jersey.

In your own bosom
you bear your heaven and
earth and all you behold;
though it appears without,
it is within.
William Blake

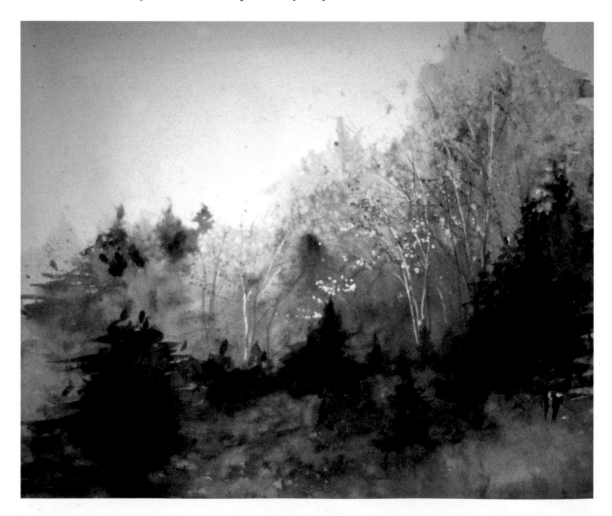

16

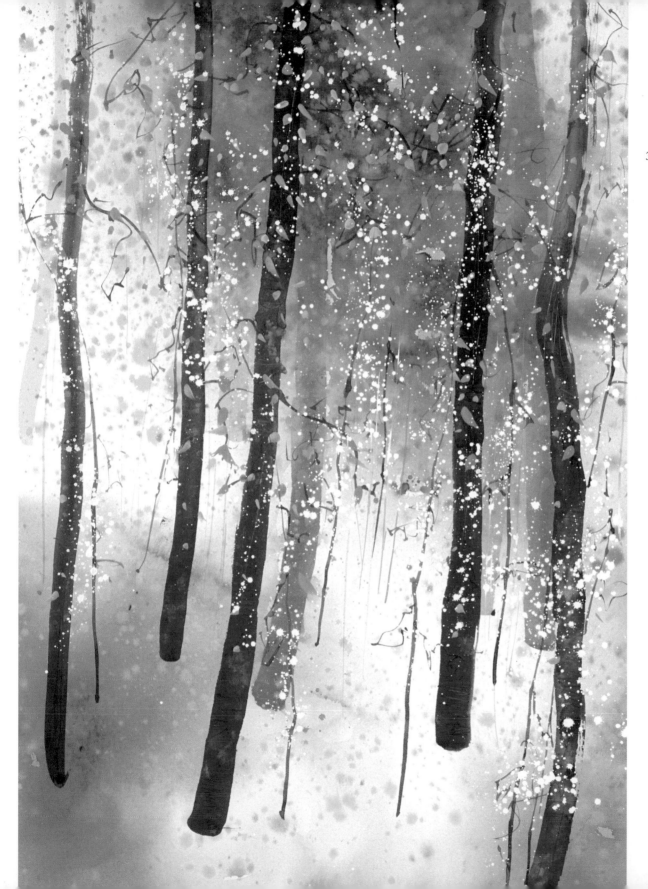

Jeanne Carbonetti
SUMMER FOREST
30 × 22" (76 × 56 cm), 1996.
Collection of the artist.

*But the artist sees
with two eyes and
alone to him is the
center revealed.*

Joseph Campbell

17

Opening to Mystery

The real voyage of discovery

consists not in seeking new lands

but in seeing with new eyes.

Marcel Proust

Jeanne Carbonetti
TULIP POND (DETAIL)
Watercolor on paper,
26 × 22" (66 × 56 cm), 1996.
Collection of the artist.

The Language of Art

Toward Creativity

Coming to terms with the deeper issues of what connects you to a painting and what does not is basic to finding your own voice in a creative process that will be both pleasurable and fulfilling. Many students I've worked with do very successful paintings, but still aren't pleased with their work. They're sure something's wrong with their technique, something they can "fix." But often a larger issue lies behind their dissatisfaction, one that's much more basic than changing colors or tonal values. They haven't yet matched their inner vision with that object out there, haven't quite said what they wanted to say about it, because they haven't released their own inner voice.

Know that by opening all of your senses, your inner vision will emerge.

At the core of all art is the question "Who am I?" For every artist it's the essential question, affecting not only the subject matter we choose to create, but how we will create it and how we envision doing it in the first place. Subject matter, style, and process are thus seductive words to artists. They weave an alluring web of intrigue that can lead us in many directions at once, often away from our true voice.

So it is with creativity of every kind. We need to know ourselves, our many different selves, so that they may come together as a whole and powerful presence.

Although I speak in this book most directly to painters, the language of creativity is universal and applies to all. Art is itself a universal tongue, and our natural visual and verbal skills make art and our interpretation of its symbols a clear and potent source of the very thing creation calls for: self-knowledge.

Because painting relates to feeling, it isn't a practical language that the artist employs, but a poetic one. When I say, "Pass the butter," I'm employing practical vocabulary, and you know to do something. But when I quote from poet Louis MacNeice, "The sunlight on the garden/Hardens and grows cold," you know that I'm not lecturing on the nature of physics as it pertains to sun rays. Quite the contrary, in fact. You are easily disposed to accept that in a poem, sunlight can "harden." Even if you're quite the literalist, you hear this as poetic verbiage and appreciate that MacNeice used the image to convey his feelings about the transience of life.

So it is with visual artists. There is a practical visual vocabulary, often universal, such as the stop sign that is octagonal and red that signals us to stop. But there is also *poetic* visual language, the stuff of art. Visually, the artist paints a tree in a certain way because that way is a closer match to his feelings about that tree than any other way of painting it. Of course, each of us could paint the very same tree and every version would look different. Why? Because we all have different feelings about that tree. Vincent van Gogh had to put a red line up the side of some of his trees, not because it was on the trees he saw, but because it was the only way to convey to viewers how he felt about those trees—the passion, and even lust with which he beheld the landscape before him. The red line wasn't on the tree, it was in him. This understanding of the poetic idiom of art led Paul Cézanne to say that one could paint the same green bottle all one's life, and that would be enough.

If the language of art expresses feelings, and if the pleasure we derive from painting comes from letting our feelings guide how we handle the medium we choose, how do we discover our true feelings? How do we learn to read the true self hiding within every piece of art?

Jeanne Carbonetti
ANNIE'S GARDEN #4
Watercolor on paper,
30 × 22" (76 × 56 cm),
1997. Collection of
the artist.

*What is essential is
invisible to the eye.*
Antoine de Saint Exupéry

woman I met
while buying
a book →
~~fry of my tea~~

☆ Infertility
around the
globe —
a paper she
had with
her →

Should I
work with
infertile
couples —
what is the
connection
between
yoga &
infertility/
fertility

21

Like King Arthur, we stand at the threshold before another world every time we create art, and like Arthur, we learn to read the signs. We do this by realizing that all our marks have meaning. They are clues from our true self, our personal vision, our Muse, revealing itself. We just need to pay attention to the signs we are given.

This book, then, is about paying attention to yourself, not only when you make art, but after you've finished. In learning to read your own marks, you begin a dialogue with the true voice behind your work. No matter which arena of life your creativity belongs to, it is this voice that holds the power.

Some fear that in seeking to know themselves as artists, their muses will retreat even further. They fear that learning the language of art is akin to analysis and too "left brain" for creativity. It's an important point, one I have played with over the years, both for myself and for my students. What has come to me is that the self we seek to know through our work, the real author of our unique vision, is always much larger than we can imagine. We can never fathom its depths completely or use up all its creative energy. Our ego selves, important though they are, are like word processors, when what we are after, the part that powers the vision, is the mainframe. Creativity of every kind goes beyond the ego self, the small self, to the big self beyond. We can never exhaust it.

Heart Versus Head

In the Zen approach to self-knowledge, we don't *make* ourselves understand; we *allow* understanding to come to us, not through logic, but through intuition. This kind of knowing is a more receptive, "right-brain" process than the more active, "left-brain" way of figuring things out. It's heart versus head. The language of art comes from the heart. To grow fluent in it is to grow as an artist.

Throughout history, the great masters who changed the definition of artistic expression all had their moment of truth when they faced themselves and broke with the tastes of their time, forever altering the course of art. This is not to say that it was easy. Michelangelo thought he would spend time in Hell, literally, for making Adam the real subject of his Sistine Chapel ceiling. Rembrandt grew out of public favor and died a pauper. Poor Vincent van Gogh, though he knew himself well as a painter, in his despair, rejected himself personally. But what each of these and other masters knew was that painting was a path, not a fixed place to be in, safe once reached, but rather a compelling force both forward and deeper to find more perfect forms for feelings greater and more intangible than before. As Zen training and all great traditions of human potential would argue, it is the only way to inner growth. And that is what creativity is all about.

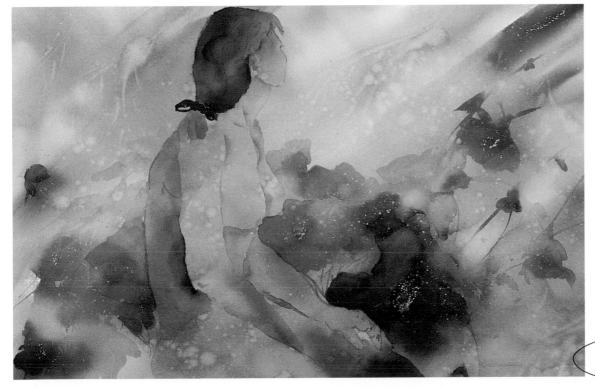

Jeanne Carbonetti
Hestia
Watercolor on paper,
12 × 30" (31 × 76 cm), 1990.
Collection of Nancy Cavanaugh.

Form is the outer expression
of inner meaning.
Wassily Kandinsky

Jeanne Carbonetti
Daybreak
Watercolor on paper,
22 × 30" (56 × 76 cm), 1996.
Collection of the artist.

When I give, I give myself.
Walt Whitman

The Way of Creation

The most visible joy

can only reveal itself to us

when we've transformed it,

within.

Rainer Maria Rilke

Jeanne Carbonetti
VALLEY OF FIRE
Watercolor on paper,
20 × 24" (51 × 61 cm), 1997.
Collection of the artist.

Toward Creativity

Quantum physics seems to be showing us now what Zen masters, seers, and prophets have known for ages: What is inside us affects what is outside us.

So it is with the creative process. Every time you think a thought, you are operating the controls of a powerful mechanism: your mind and its ability to envision. In art as in life, when a thought recurs many times, which harnesses the power of intention, the world can change.

From the moment we are born, our birthright is to play with the great creative process that is our life. As we grow, we direct that creative power into certain channels. We become aware that life doesn't just happen *to* us; we affect life, whether through deliberate choices or unintentional habits.

This awareness is probably quite strong in you. Being drawn to this book, you are probably a person with a creative temperament—an artist. In fact, the original meaning of the word *artist* in Sanskrit was "one who sees things fitting together." Creative people are those who get beneath the surface of things to the meaning that is presented through the flux of changing forms. They react to one situation as a piece of a larger continuum. Creative people see relationships.

What is most essential to you and me as creative artists is that we *feel* the way things connect to one another, that we understand, in a personal way, the relationships implied. Life, then, isn't just observed; it's felt. Life doesn't go around us; it goes *through* us. And I think it goes through us in a very special way.

The Consciousness of Creation

We are each a funnel for spirit, which could also be called life force, or the field of possibility. It comes through us by way of our three-part self: our Body Mind, which feels; our Logical Mind, which thinks; and our Heart Mind, which synthesizes both into understanding. In a beautiful spiral dance, body, mind, and spirit clarify our special gift and goal by pulling us downward from a general sense of what we know, through what we love, to the specific awareness of what we want. The process by which spirit becomes matter is a universal one, yet we each have our own rhythm for moving through it.

A major tenet of this book is that our natural verbal and visual abilities are already in place, along with all sense perceptions, to help us see and speak with our full creative self, the true self. Although usually hidden from our consciousness, it is the source of our unique frame of reference because it speaks in the language of feeling and symbol, and that is the world of art. Whether we choose to be artists or create in another realm, to make art is a clear and simple way to know ourselves, to see ourselves in symbolic form, and to listen to ourselves speak through the language of the principles of visual harmony.

as Carolyn Myss tells us to look at ourselves through archetypes

Thus, art is for everyone, just as language is for everyone, just as kinesthetic feeling, our body's senses, help us all to come to the wisdom of the self, which is our Muse. This self is whole, for it encompasses the three fundamental traits of human awareness: our understanding of beauty (Body Mind: What do I feel?), truth (Logical Mind: What do I know?), and love (Heart Mind: What do I choose?). It is the sacred triangle of the family within—the mother, father, and child within us—the mind of creation itself living as us.

When you allow those three parts of yourself to come together, so that your knowing is not partial but complete, letting each have its say without repression or judgment, they move together in a beautiful song, like different instruments becoming one harmonious symphony. The self, your Muse, is the symphony of your body, mind, and spirit, playing together as one in a supremely concentrated moment that is your unique creative gesture.

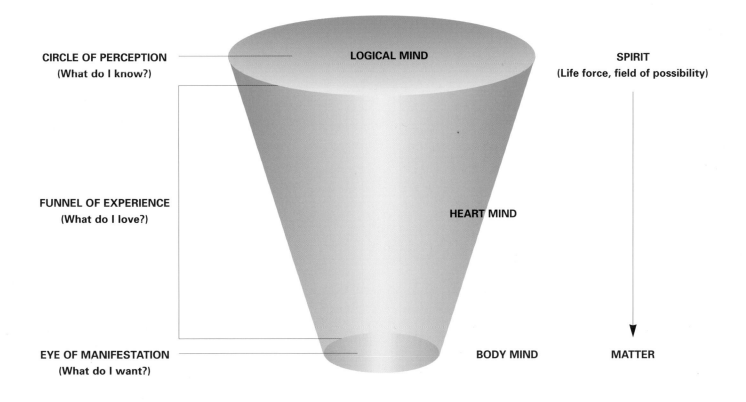

CIRCLE OF PERCEPTION
(What do I know?)

LOGICAL MIND

SPIRIT
(Life force, field of possibility)

FUNNEL OF EXPERIENCE
(What do I love?)

HEART MIND

EYE OF MANIFESTATION
(What do I want?)

BODY MIND

MATTER

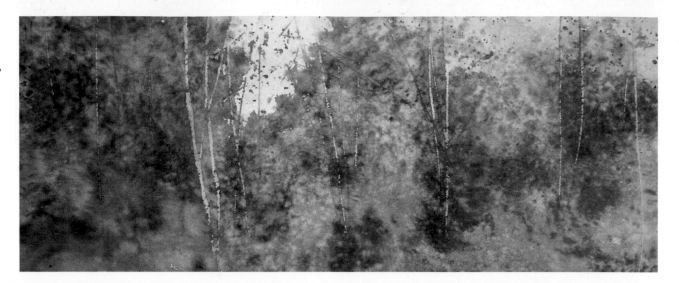

Jeanne Carbonetti
EDEN'S SPRING
Watercolor on paper,
13 × 30" (56 × 76 cm),
1985. Private
collection, New York.

Everything is
related to
everything else.
Leonardo da Vinci

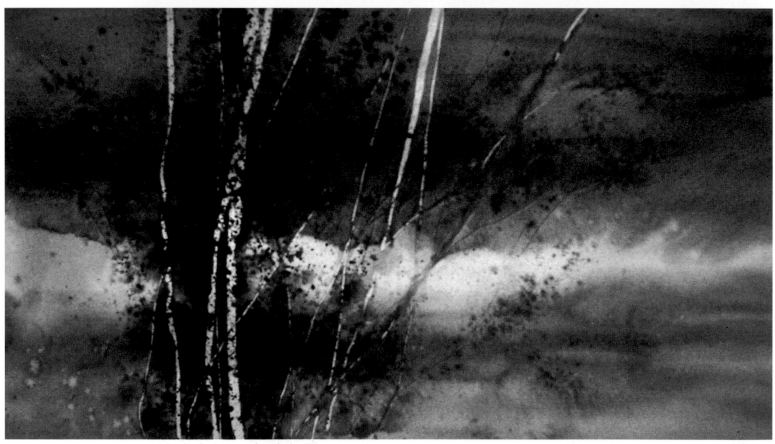

Jeanne Carbonetti
NOVEMBER STORM
Watercolor on paper, 22 × 30" (33 × 76 cm),
1986. Private collection, New York.

The universe is change; our life is what
our thoughts make it.
Marcus Aurelius Antoninus

Jeanne Carbonetti
WINTER BLUE
Watercolor on paper,
30 × 22"
(76 × 56 cm), 1988.
Private collection,
Rhode Island.

As he thinketh
in his heart,
so is he.

Proverbs 23:7

The Mind of *Creation*

Y ou are consciousness itself, the conduit through which spirit becomes matter. Without you, it cannot happen. Moreover, each of us is conceived differently to shape spirit into a special form of matter.

How do we do that? Picture yourself as the funnel of creative consciousness shown earlier. At the top of your head is the largest circle of perception; at your feet, the smallest. Just outside your funnel is your Body Mind, the site of all information that comes to you awake or asleep, such as gut reactions and dreams, in an instinctive, bodily way, forming the big picture.

Next, move to the inside of your funnel, to the consciousness of Logical Mind, the analytical part of you that comes to practical conclusions quickly, separating pieces of the pie into one slice at a time, thinking in a linear way. The great gift of Logical Mind is that it can focus.

Now go to the rim and sides of your funnel to Heart Mind, which brings Body Mind and Logical Mind into relationship so the three become one, making you whole. Heart Mind thinks, feels, and *understands,* supplying answers that satisfy us.

But even though this triad is universal, how we operate in it is unique in each of us. In her book *The Art of the Possible,* Dawna Markova suggests that with the three major perceptive modes—seeing, hearing, feeling—each sense is perceived differently in each consciousness. In my case, in Logical Mind, I'm visual; if I can see something, I can learn it. In Body Mind, however, I'm kinesthetic and need to move or be touched in order to connect with my feelings. In Heart Mind, my perception is verbal. Thus, I've found that writing books actually helps my painting because it aids me in understanding connections that are essential to me now.

From a functional point of view, this self-awareness is important. Too often we judge ourselves as not smart enough, quick enough, or perceptive enough in some capacity, when all that needs to be changed is the mode of perception. This premise presented itself to me profoundly one day as I was working with a student. Because I process with words, I was trying to talk her through a difficult passage in her painting. The more I talked, the more tense she became. Suddenly, midsentence, I realized she needed something visual, not verbal, so I grabbed my brush and paper, did a few strokes, and immediately she said, "Oh, I *see* what you're saying."

Ever since that awakening, I've been very conscious of how we each take life in. For the artist, such knowledge can help tap the resources of our Muse just by changing our language of perception. By moving from visual to verbal, I tap another aspect of myself. And to get them all present at the same time, I center myself every time I become mindful of what I'm seeing, what I'm hearing, and what I'm feeling. I see the paper before me instead of just writing on it; I feel the chair beneath me; I hear the December wind outside my window.

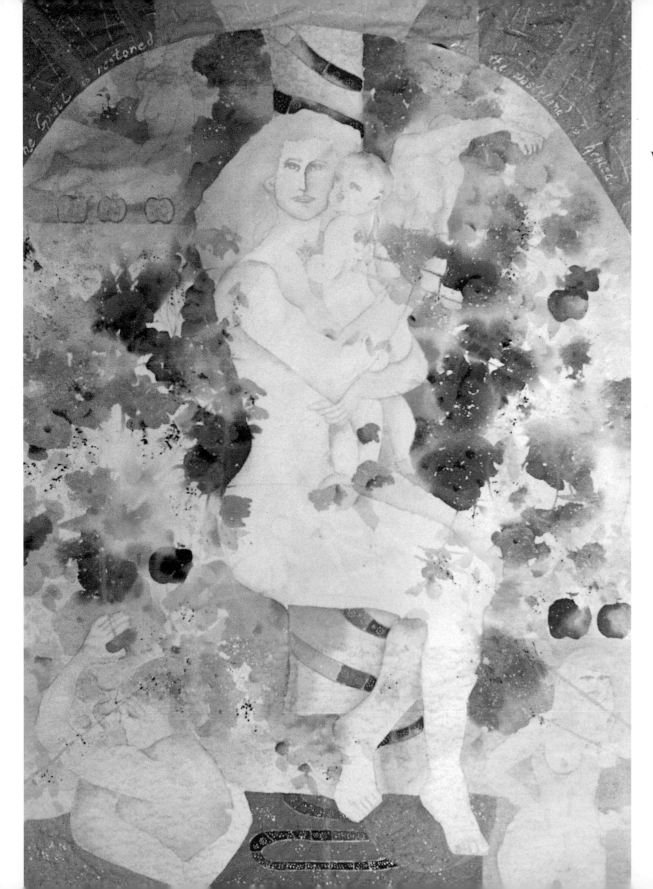

Jeanne Carbonetti
HOLY GRAIL
Watercolor collage, 60 × 40"
(152 × 102 cm), 1994.
Collection of the artist.

*What you would
dare to be, begin it!
Genius has
boldness in it.*

Johann Wolfgang
von Goethe

31

Each part of us has its own special insight at any given time, and each speaks in its own language. The synergy of the three together, body, mind, and spirit, is the bigger us behind the veil, the true maker of the magic. It is either magic or mayhem, depending on how conscious you are of where you are on this circle of perception. While the creative process itself is universal, we each move through this process in a very personal rhythm.

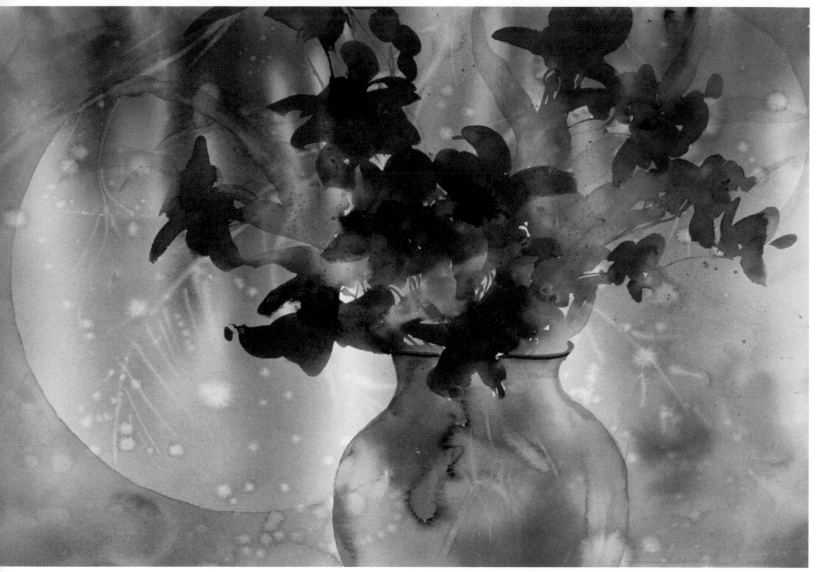

Jeanne Carbonetti
Daylilies with Moon
Watercolor on paper, 22 × 30" (56 × 76 cm),
1994. Collection of the artist.

The imagination is our true self, and is in fact the living,
creating God within us.
Stephen Nachmanovitch

Jeanne Carbonetti
Buddha's Vases
Watercolor on paper, 22 × 30" (56 × 76 cm),
1997. Collection of the artist.

The primary imagination I hold to be the living power and
prime agent of all human perception.
Samuel Taylor Coleridge

The Spiral Dance of Creation

The funnel of our consciouness, depicted earlier, comprises circles of perception, from the largest at the top to the smallest at the bottom. This downward spiraling dance begins with the Body Mind question that often presents itself as an uneasy feeling that something is awry and about to change. It makes its way into our conscious Logical Mind for research and development. Now we know what the question is, although not yet the answer. But just knowing the issue brings us comfort. Answers come from the rim of the funnel, where a certain incubation stage is required as Heart Mind mediates between the vastly different worlds of Logical Mind and Body Mind. But the wait is worth it, for when a breakthrough comes, in that final moment of unity all is one. Now, as we allow ourselves to play with our dreams and use our imagination, something wonderfully new and original is formed.

Jeanne Carbonetti
DANCE OF THE SEVEN VEILS
Watercolor collage,
40 × 60" (102 × 152 cm) , 1994.
Collection of the artist.

*It is no longer a passion
hidden in my heart.*
Jean Racine

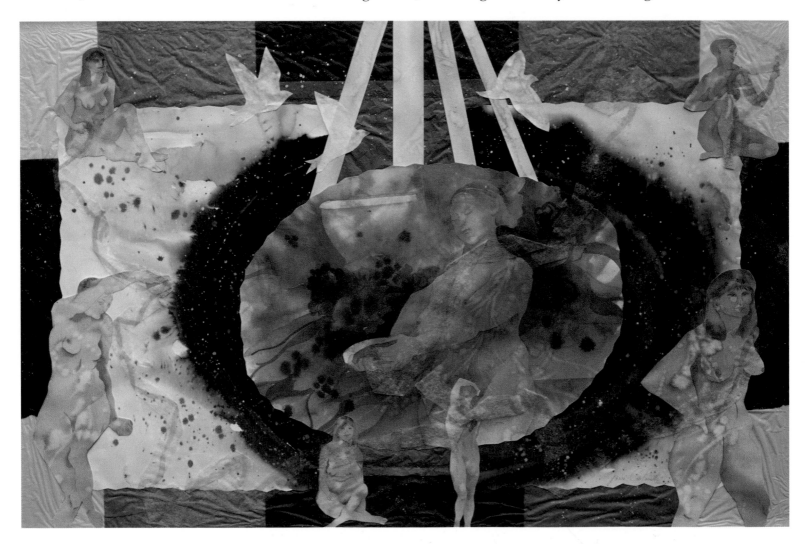

Jeanne Carbonetti
AFFIRMATION
Watercolor on paper,
30 × 22" (76 × 56 cm),
1991. Collection of
the artist.

Great dancers are
not great because of
their technique;
they are great
because of their
passion.
Martha Graham

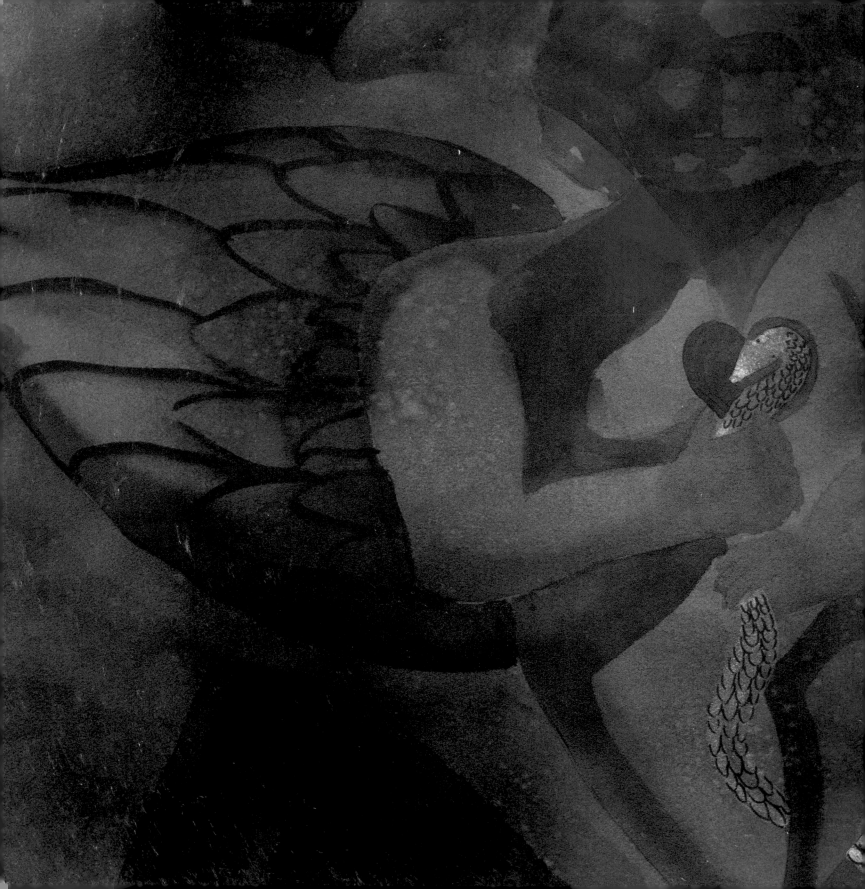

Body Mind

Art is the proper

task of life;

art is life's

metaphysical exercise.

Friedrich Wilhelm Nietzsche

Jeanne Carbonetti
JACOB'S ANGEL
Mandala in watercolor on paper,
22 × 30" (56 × 76 cm), 1995.
Collection of the artist.

Toward Creativity

Being aware of your body's immediate signals, paying attention to your dreams, and recognizing the archetypal patterns you may be living out are all ways of receiving valuable information about yourself that can aid in the creative process. Try keeping a dream journal. I find mine to be an invaluable tool. When I read my dreams like paintings, as symbols rather than literal narration, they provide me with a wealth of creative inspiration. The final version of this book, in fact, resulted from a dream that instructed me to find its deeper structure.

Another way to think of the Circle of Perception is as a great satellite dish, collecting signals from the vast region of the larger consciousness that exists beyond the rim of the circle. Remember that the whole funnel of your experiences is a series of increasingly more concentrated circles of perception, so this great Body Mind is ever present and available to you, to help you find your Muse.

In the world of diffused consciousness, Body Mind's information comes to us automatically; we don't have to conjure it up. It speaks to us through instinct and is collective, for it comes not just from one body's knowing, but from a whole species' knowing, as in our DNA, which carries the strands of human evolution forward in time. Our bodies are barometers of a large source of knowledge. Myth, meditation, dreams, and body language all speak to us from this great collective awareness.

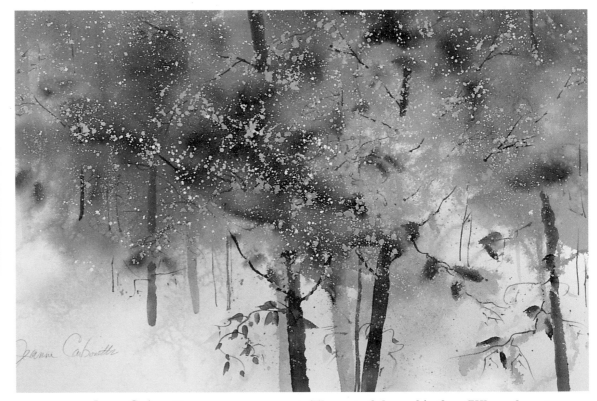

Jeanne Carbonetti
SUMMER TREES
Watercolor on paper, 22 × 30" (56 × 76 cm),
1997. Collection of the artist.

The seat of the soul is there/Where the outer and inner worlds meet.

Novalis

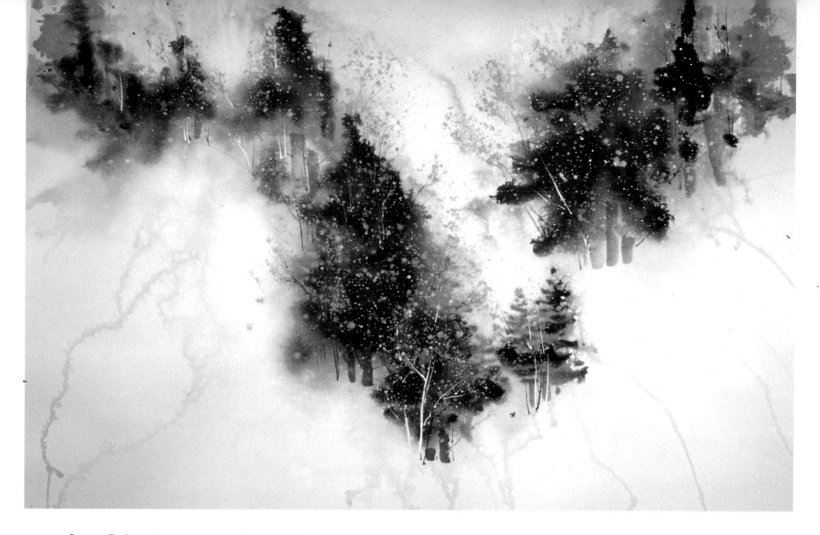

Jeanne Carbonetti
OKEMO MOUNTAIN
Watercolor on paper,
22 × 30" (56 × 76 cm), 1990.
Collection of the artist.

All paths lead to
the same goal:
to convey to others
what we are.
Pablo Neruda

Scientists tell us now that mind is in every cell. What we think, we become; we *embody*. It's an awesome notion. Psychosomatic no longer means "It's in your head," but that there is a direct link between body and psyche. Dr. Deepak Chopra states that anytime we react to anything, there is immediately a response of either pleasure or pain within our bodies. Our Body Mind speaks to us all the time, whether within the skin and bones we occupy in waking consciousness, or in the body we occupy in our dreams or archetypes of myth. They all give us signals and symbols that come from that part of ourselves that sees the whole pie, rather than just a slice. Marion Woodward, a psychologist specializing in dreams, has said that dreams often speak to us of issues that may be twenty years ahead of us, for they often speak of the very largest patterns in our lives.

As we take in more experience and more life, we garner more potential for creativity. We feel the first stirrings of something brewing, the start of the beautiful question that usually begins with a kind of anxiety. This restlessness is the action of Body Mind trying to work its way up to our focused consciousness. If we want to receive the gift of Body Mind, we must allow ourselves to be with the sensation of unease, and patient enough to listen for subtle signals. The more we do, the louder and clearer will come the voice of our Muse.

The Ways of Meditation

B eing with the collective body directly, by stilling the mind's inner dialogue, can be achieved through meditation. Its purpose is to honor parts of ourselves hidden from conscious view, not in symbol, as in art, but experientially and immediately. This is the realm of pure being itself, a world of infinite wisdom and peace because it is the place where all forms merge into oneness. Of the many kinds of meditation, two forms that are most accessible to Westerners are: insight and transcendental.

In insight meditation, one focuses on the breath and allows physical sensations, feelings, and thoughts simply to come and go. Our only awareness of them is as they pass through our consciousness. Through this practice, we realize that the self is the witness to all changes and is not attached to any one.

In transcendental meditation, the focus is being itself, the silence between all thoughts, feelings, or sensations. In order to reach this state, one repeats a mantra—a symbolic sound such as *om*—which gradually fades away until silence is perceived.

I find both types of meditation helpful. Insight meditation emphasizes being with something; in transcendental meditation, the emphasis is on being itself, where there is no longer any object to witness at all. These and other meditation methods all have in common a way of moving from thinking to being—a beautiful experience that enhances the creative process.

Jeanne Carbonetti
SUMMER TREES
Watercolor on paper,
22 × 30" (56 × 76 cm), 1997.
Collection of the artist.

*Form is the outer expression
of inner meaning.*
Wassily Kandinsky

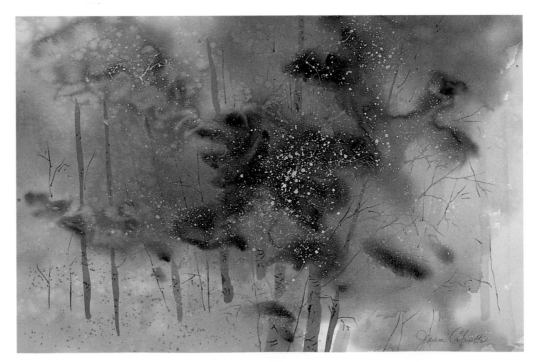

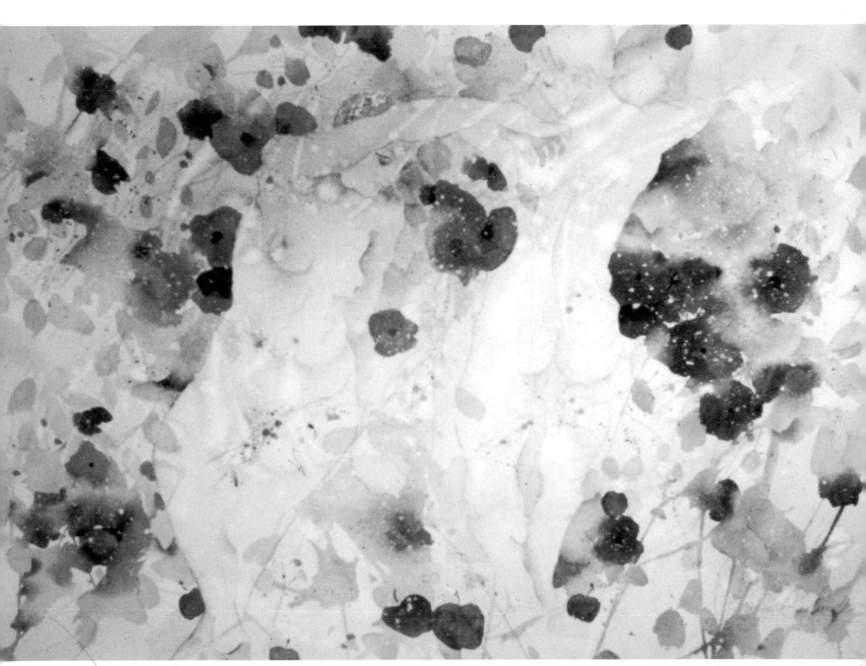

Jeanne Carbonetti
THE NEW GARDEN
Watercolor on paper, 22 × 30" (56 × 76 cm),
1994. Collection of the artist.

Painting is silent poetry,
and poetry painting that speaks.
Plutarch

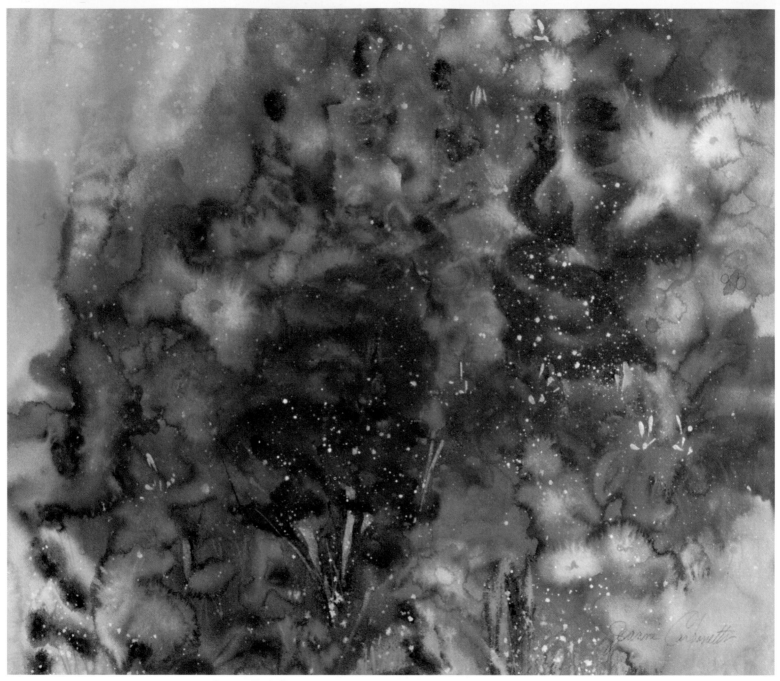

Jeanne Carbonetti
ANNIE'S GARDEN #3
Watercolor on paper, 22 × 21" (56 × 53 cm),
1997. Collection of the artist.

Imagine your heart as an opening lotus.
From its center comes a crimson child,
pure, virginal, innocent.

Deng Ming-Dao

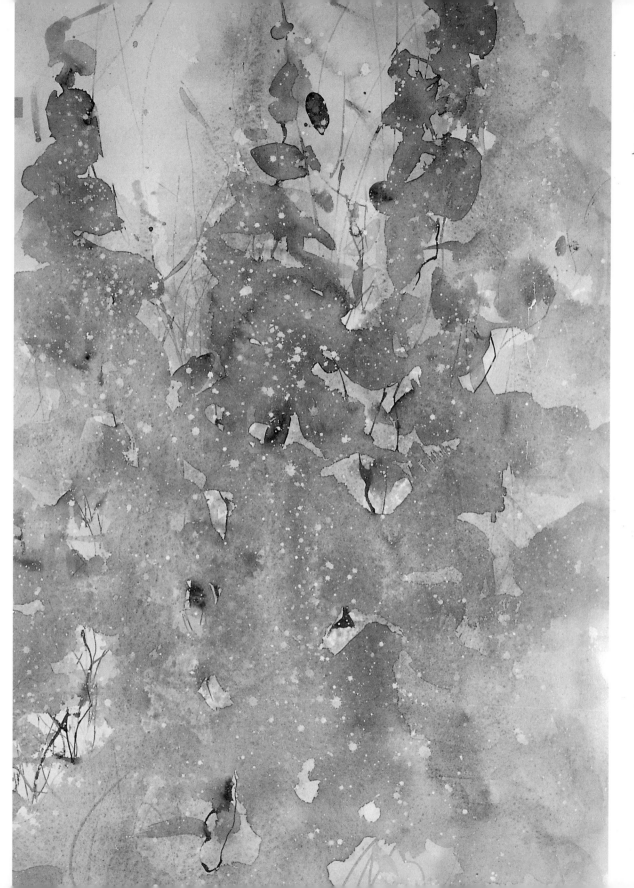

Jeanne Carbonetti
**DELPHINIUM
AFTER THE RAIN #2**
Watercolor on paper,
26 × 22" (66 × 56 cm), 1989.
Collection of the artist.

*I had a dream which was
not all a dream.*

Lord Byron

The Language of *Abstraction*

Is there a way to *see* Body Mind, some way of having a vision of this part of the voice of the Muse on paper, in concrete form? Yes, there is—through the language of abstraction.

Abstraction is a form of communication that doesn't use realistic, recognizable forms that exist in the visible world. Instead, it relies on the principles of visual or artistic harmony themselves—focus, composition, value, color, and texture—to tell a story. We each have an instinctive sense of these principles, which is why we're able to respond to art in the first place.

To work abstractly is to work directly from the unconscious, in a way that is similar to meditation. I've found that for each of my students who has an ease in Body Mind awareness, abstraction is what fulfills their vision as artists. They simply are bored by anything else. As a teacher of painting and drawing, I'm very aware that this aspect of our consciousness needs to be present and honored first, before any kind of art, no matter how realistic, can be produced.

Jeanne Carbonetti
Autumn Birch
Watercolor on paper,
13 × 18" (33 × 46 cm), 1997.
Collection of Muriel Walter.

The answer, my friend,
is blowin' in the wind.
Bob Dylan

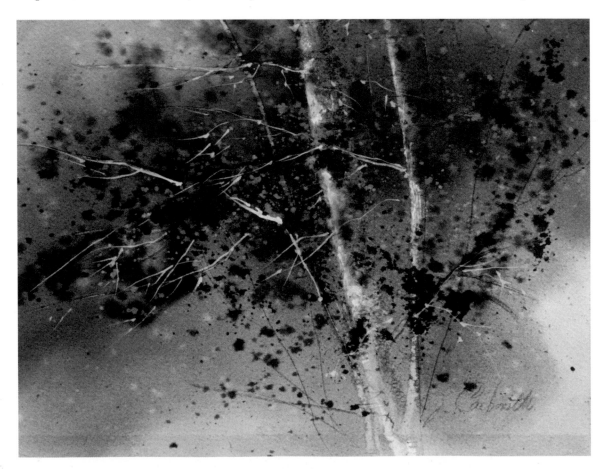

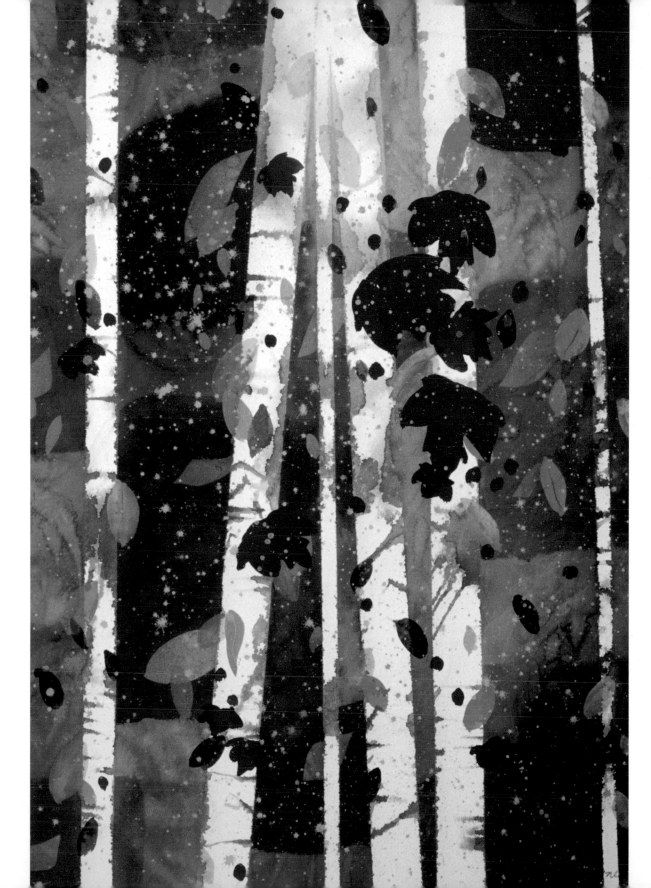

Jeanne Carbonetti
Kaleidoscope Autumn
Watercolor on paper,
30 × 22" (76 × 46 cm), 1997.
Collection of the artist.

Art is not a thing;
it is a way.

Elbert Hubbard

45

Revealing the Self Through Mandalas

Toward Creativity

Whenever we make art, we are unveiling the true self, the one that includes all other parts of ourself that we allow to speak. But in order to hear what the true self has to say, we must be fluent in its language of images and archetypes. These, and the principles of visual harmony, can be learned through the mandala.

A simple way to begin working abstractly is with a mandala, a word meaning "magic circle" in Sanskrit. Used as a Hindu or Buddhist graphic symbol of the universe, the circle is enclosed in a square with a deity at each corner. In Western culture, the mandala was adapted by psychologist Carl Jung as a way to bring consciousness into a concrete form that could be read, much as one reads a dream. Jung also ascribed healing powers to the mandala. He believed that by putting personal symbols together in a circle, which itself symbolizes the wholeness of the psyche, many parts are brought together in harmony. For Jung, all parts of the psyche need to have their honored place for healing to occur.

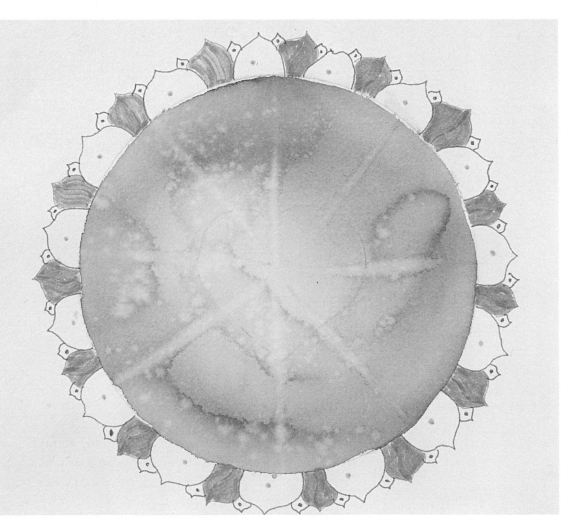

Jeanne Carbonetti
RADIANT HEART
Mandala in watercolor on paper,
12 × 12" (31 × 31 cm), 1993.
Collection of the artist.

A dream, too, is from Zeus.

Homer

Jeanne Carbonetti
WRESTLING WITH ANGELS
Mandala in watercolor on paper,
22 × 23" (56 × 58 cm), 1995.
Collection of the artist.

*At the still point of the
turning world . . .
there is only the dance.*
T. S. Eliot

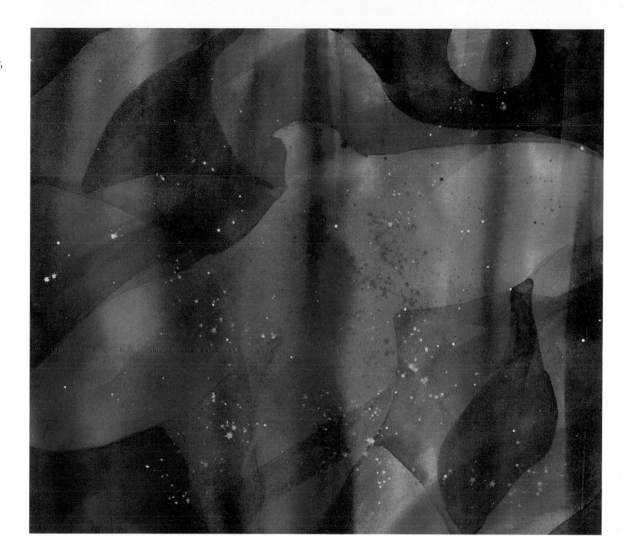

 In the creative realm, mandalas present images of our wholeness, for they bring forth our other side, the side usually hidden from view. There is tremendous power in the mandala drawn from the great body of visual imagery that is our collective heritage. For example, the sun is a universal symbol of light, day, activity, and is associated most often with something good. The whole realm of mythology and dream is based upon our shared, archetypal understanding. Mandalas are powerful forms of art because they can house anger and pain, give form to even violent tendencies, express grief and regret—all within a safe, and even sacred, framework. I have found that mandalas have the uncanny ability to honor not only what is with us now, but also to show us where we are going. Process always seems to be an important thrust of the mandala's message. It always shows us that we are bigger than we think we are; that our knowledge is greater than we know. Mandalas never lie.

Although mandalas are usually held within a circular format, for our purposes, I feel it's beneficial to begin with any shape that feels appropriate. Here are the simple steps to follow:

- Set aside twenty minutes, and find a quiet place in which to work.
- On a piece of paper, draw any shape that feels right—triangle, square, oval, or just a form that isn't anything specific. Wait until one particular shape grabs and moves you before setting it down.
- With markers, crayons, pastels, and/or colored pencils, fill in this shape in whatever way you wish, but using *only abstract forms*. It's better for this exercise not to make a tree, a dog, or any other realistic depiction. Also note that while some of the examples on these pages are in watercolor, for your first mandalas it's best to use a medium that doesn't require drying time.
- Continue until your piece feels finished.

Diamond of Sun is the first mandala Meg had ever done. I was immediately struck by the diamond shape that enters the picture, and the relationship of the sun to the darker wavelike shapes beneath. The movement in composition is downward, as if the sun's rays are cutting through the denser sludge beneath. The quick-moving textural strokes of blue seem to reinforce this. For Meg, it meant that the sunlight of her consciousness was breaking through and clearing her old griefs (the purple) and bottled-up emotions she never voiced (the blue). The four corners (in mythology, four represents wholeness) illustrate the way her diamond of self was being formed—through the work of getting grounded, indicated by the red, orange, and yellow triangles (earth centers) moving to healing green.

Although Meg had never painted before this workshop, she was excited and surprised when she produced the figure painting *Mirror, Mirror, on the Wall*. She hadn't planned the light, which is the focus of the piece, but was struck by the similarity of it to her mandala and by the hope of its message. As she gazes in the mirror, she sees her own light. This painting reassured her it is there.

Mandalas are art forms that can put meaning into concrete forms of beauty based upon our universal understanding of the principles of visual harmony. Let's examine those principles, for beauty is the harmony of all the parts of the whole.

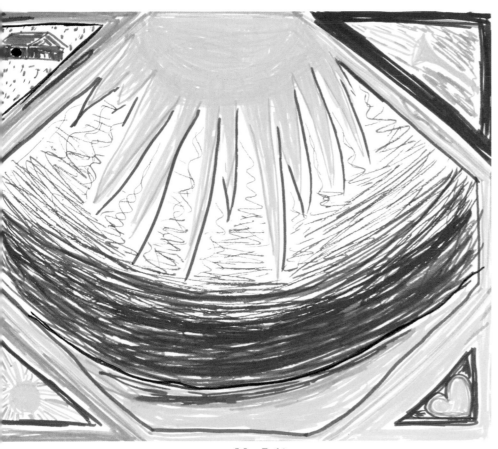

Meg Robinson
DIAMOND OF SUN
Mandala in markers on paper,
12 × 13" (31 × 33 cm), 1997. Collection of the artist.

To a poet nothing can be useless.
Samuel Johnson

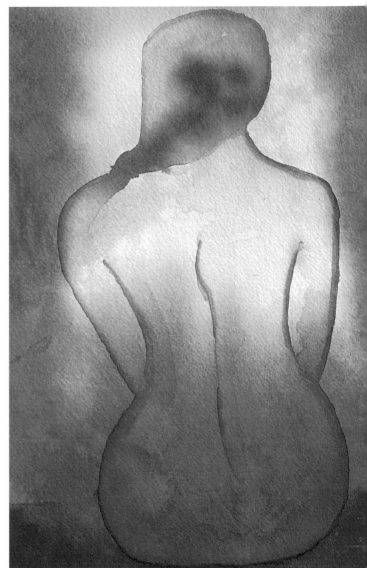

Meg Robinson
MIRROR, MIRROR, ON THE WALL
Watercolor on paper, 15 × 7" (38 × 18 cm), 1997.
Collection of the artist.

We feel and know that we are eternal.
Baruch Spinoza

No matter how realistic a painting is, it is abstract first, because all art is based on abstract principles of visual harmony. I've seen good paintings fall apart at the end because a student stayed in a realistic mode, playing with an object, rather than dealing with basics. Thus, when Joe thinks something more is needed as he finishes his painting, it's probably not another pumpkin here or apple there, but rather a bright spot of warm color, more texture, or another aspect of visual harmony.

Your growth as an artist comes from reading your own work, seeing the next step, and knowing how to proceed. Since images speak in the language of the visual, to read them you must become fluent in the six principles of visual harmony: story, focus, composition, tonal value, color, and texture. These are tools by which you read your mandala to receive its guiding message for your artwork.

To lead you through these principles, let's use *Water with Lilies* as an example. Of all my work, I consider this to be my masterpiece, the painting that more closely than any other is *me*.

The Story of the Image

Every image projects a story line of some sort. What does it say to you at first glance? In *Water with Lilies,* immediately, a strong emphasis is seen on the movement, which establishes a waterscape of flowing, merged forms, rather than isolated objects. Unlike landscapes that lead from one thing to another, here, you hit the final resting place head on, rather than meandering through other things to get to it. An opening calls to you, but it remains a mystery to explore if you wish, or just know that it's there. My painting is about touching earth forms lightly and being transported to the mysterious oneness of heaven, simply and quietly.

Focus

The spot that draws your eye the most in a painting is its focus, the anchor of the piece that pulls all the elements together, guides your movement, and holds you ultimately. My focus is quite singular, and you hit it at once in the pink flowers where they juncture with light on the water. The tone of my piece is thus extremely quiet, and if you choose to move to the light, you proceed back and down, for the light comes from below. One's concentration on focus in this picture is much like a pebble thrown into a pond, rippling the water outward in rings.

Composition

Like a jigsaw puzzle, composition is concerned with how all the pieces fit together— the positive, painted space, as well as negative spaces—those areas around filled space.

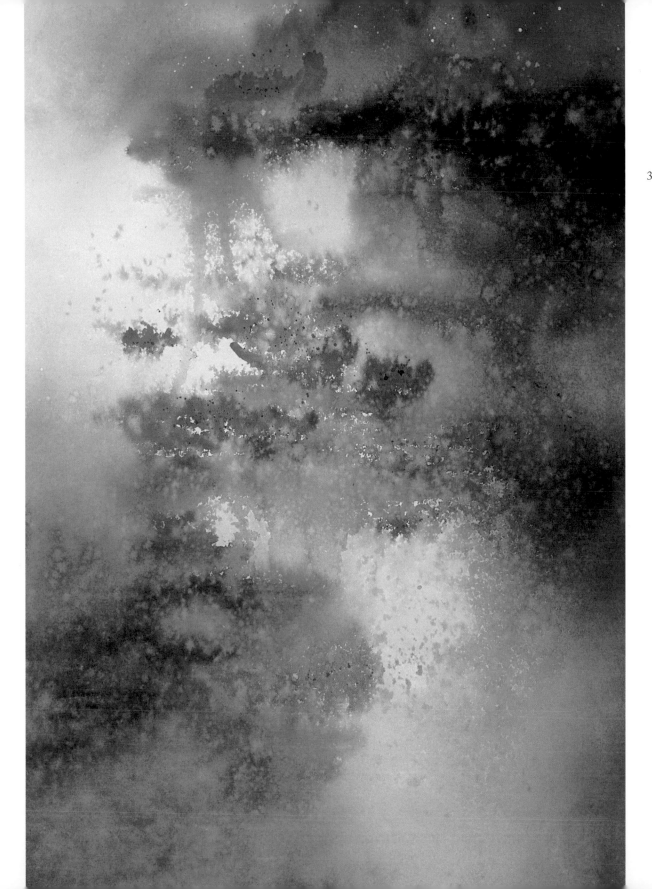

Jeanne Carbonetti
WATER WITH LILIES
Watercolor on paper,
30 × 22" (76 × 56 cm), 1987.
Collection of the artist.

*Nature does nothing
uselessly.*
Aristotle

Composition has a lot to do with balancing shapes in one area of a painting with other areas. *Relationship* is the key word here, how pieces relate to one another within the whole. Good composition should take you to the leader—the focus, in a rhythm fitting its story.

Although *Water with Lilies* has a vertical format, a square area of focus takes the viewer dramatically toward the center where pink flowers anchor the eye. Only an echo of this color radiates outward, not enough to pull your eye. Instead, dark areas serve as a means of rotating the composition outward from center in the gentle flow of an S-curve of light that creates another graceful rhythm, subtle and hushed, away from the lilies.

Value

The lights and darks in a painting are its values. Generally speaking, lightest lights, darkest darks, and brightest brights go toward the focal point, while medium values neutralize spaces away from the focus. Medium values provide the volume for most of a painting, so they need to be varied enough without being too obvious.

Here, the lightest light occurs just north of the pink focus where the brightest values are found; darks form a circle around the center, but then they trail a bit to include edges

Jeanne Carbonetti
LOVE STORY OF
DAVID AND RACHEL
Mandala in watercolor on paper,
22 × 30" (56 × 76 cm), 1996.
Collection of the artist.

Love conquers all things;
let us too surrender to love.
Virgil

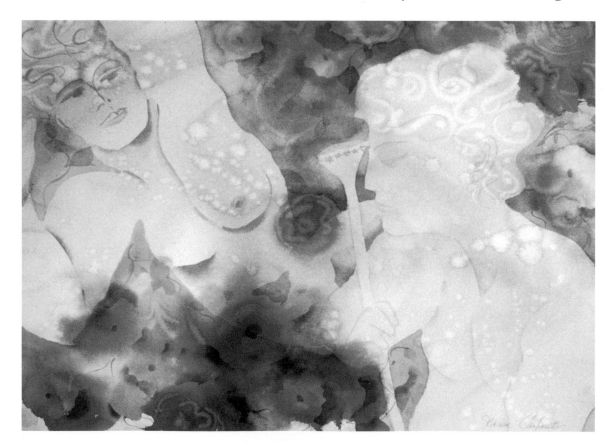

of the painting. The range of values is simple, but the changes in blues and greens keep the medium values varied.

Color

The most difficult principle of visual harmony to specify is color, precisely because we tend to think of it the least in terms of its dynamic effects. We think it's just a matter of picking a palette that we like. But colors affect one another, just as they affect us, in many ways. *Color Temperature* is one aspect. Warm hues are reds, oranges, yellows; cool hues are blues, greens, purples, the palette in *Water with Lilies,* where colors flow together gently and allow the viewer to see everything as one entity, in an elegant, smooth way, making a quiet transition from earth to spirit.

For your general reference, these are the basic *Color Systems:*

- Monochromatic: single hue, different values; quietly dramatic in feeling.
- Analogous: colors next to each other on the color wheel; smoothly transitional in feeling.
- Complementary: colors opposite each other on the color wheel (red/green, orange/blue, yellow/violet); dynamic in feeling.
- Primary: red, yellow, blue; primal, fundamental in feeling; can be discordant in equal amounts.

And drawn from mythology, psychology, even Kirlian photography, here are some themes relating to the *Psychology of Color:*

- Red: groundedness, vitality, passion.
- Orange: creativity, personal power, emotions.
- Yellow: consciousness, awareness.
- Green: growth, nurturing, opening.
- Blue: expression, willpower.
- Violet: intuition, wisdom.
- White: light, completion, oneness.

Texture

The final principle of visual harmony, texture, concerns itself both with the object being depicted (e.g., tree bark) and the medium itself (e.g., oil, watercolor). Texture is the feel of a thing, whether it's the object or the medium.

In *Water with Lilies,* it's the texture of water and its flow that I'm after—flow, above all else. By using wet glazes of pure mineral pigments on top of each other, one color at a time, I create depth and color drama in support of flow. This, to me, is what the world really is. Nothing is quite as solid as it seems, and nothing is, but what it is becoming. Many landscape paintings say, "Earth is divine. Can't you feel it?" Mine whispers, "Heaven is right here. Can't you see it?"

Now let's see how the six principles of visual harmony reveal themselves in a mandala that I created just before beginning work on this book, the second in a series of three. It was during a period of restlessness and worry over my pressing obligations, and it proved to be tremendously helpful in moving me along.

Story

When I put my mandala on the floor, there was the story, loud and clear; all I needed was a train whistle! I was totally unaware, as I worked on it abstractly, that it would read this way. But a train coming through a tunnel was obvious and reassuring, pointing full steam ahead, out of the tunnel. Note what could be a stone wall that the train has barreled right through—a breakthrough expressed visually.

Clearly, the eye goes instantly to the powerful engine coming right toward the viewer. Or, is that a face with two giant eyes, a nose, and mouth? It's most likely both.

Composition

The movement back to front creates a sense of rapid motion, and I see the triangle formed by the circles as symbolic of my three books. The wall flanked by pillars forms a striking division between back and front, and the double image of arch (in the tunnel) and pillars becomes a threshold crossing. The wall itself has the look of a zipper, as if opening up.

Value

Purple forms the darkest value, shaping the tunnel out of which my train emerges. The gradations are simple and clear-cut rather than grayed or muddied, imparting a quality of lightness, a movement from dark to light.

Color

A rainbow of colors was used, all in their primary hues (for example, red rather than pink), producing a childlike quality of exuberance. I was interested in the tunnel being purple, to me, the color of the third eye, the place of wisdom and intuition. This told me that the train is moving from that place of understanding, and it put my fears to rest about my readiness. That the tunnel was rimmed with red diamonds reinforced this feeling, as diamonds symbolize something of rich value, jewels that comes from great compression, or work. The color red speaks to me of groundedness, like the coal from

Jeanne Carbonetti
THE TRAIN IS COMING IN
Mandala in markers on paper,
10 × 14" (25 × 36 cm), 1997.
Collection of the artist.

*Vision is the art of seeing
things invisible.*
Jonathan Swift

which diamonds come. My journey into light, says my mandala, has been one of learning groundedness, the divinity of all that is earthly, including my own body, and giving it form—these books.

Texture
I was struck by the fairly deliberate and even quality—an evenness of pacing, rather than a restlessness. I was glad to see that, for it, too, said I was ready—that my train was coming in!

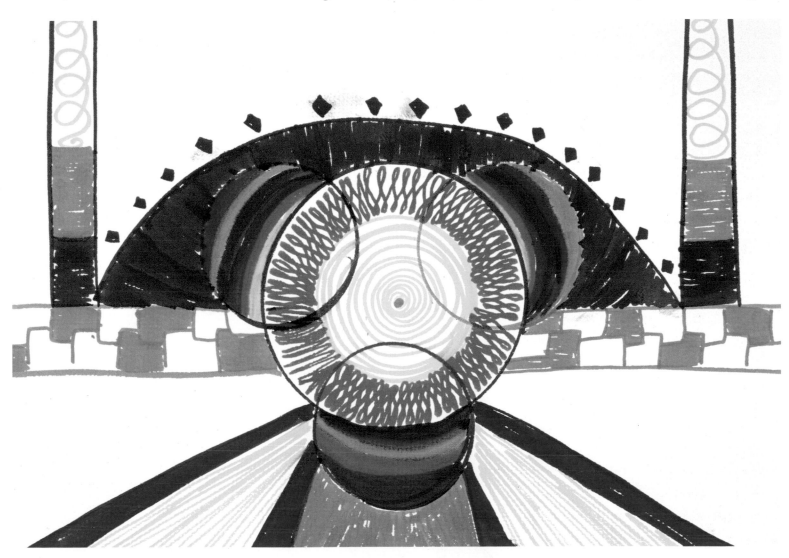

As I analyzed my mandala, in like manner, examine mandalas of your own, listing for yourself the following:

- Story: What's your first impression? Does it suggest something?
- Focus: Is there one? Is it clear?
- Composition: Are there strong lines in one direction, such as diagonals, verticals, horizontals? What kinds of shapes are present?
- Values: Is it dark or light? Is there a range?
- Color: Is it warm or cool? Is it monochromatic, analogous, complementary, or primary? Is it clear, clean, or otherwise?
- Texture: What are the kinds of strokes used? Are they deliberate, even? Is there a change in stroke anywhere?

Turning now to another mandala: This one, by Carmen Fletcher, has a *story* that speaks immediately of exuberance and the well-ordered consolidation of tremendous power. Indeed, it looks like a shaman's rattle, those revolving circles held together by the spine in the center that leads to the "eye" of the blue feathers. There's a lot of motion here, but it's not chaotic at all. The *focus* is clearly on the eye, holding it all together, but we're also drawn to the bridge of light in yellow and green intersecting the spine and connected to it. In *composition,* it has a birdlike quality and is clearly "lifting off," as indicated by the space at the bottom. In *value,* the darkest lines on two sides of the central circle accelerate the sense of motion, and in *texture* and *color* this is even further reinforced by the rolling convergence of many curved and convex forms.

I couldn't help but think of the three modes of consciousness: Logical Mind (the eye on the left), Body Mind (the seaweed and seal-like form on the right), and Heart Mind, which bridges the other worlds and leads us to the eye of enlightenment. Afterward, Carmen, a psychologist by vocation, shared that recently she had been told by a mentor that she would one day be a great healer.

Understanding these concepts gives you the ability to read your own works of art, for every piece of art is a portrait of our souls; that is, all art is fundamentally a mandala. With these simple tools of perception, you can craft your own work of art and then dialogue with it when it's done. It will not only show you where you are, but where you are going. It will reveal you to yourself in what is always a fascinating experience.

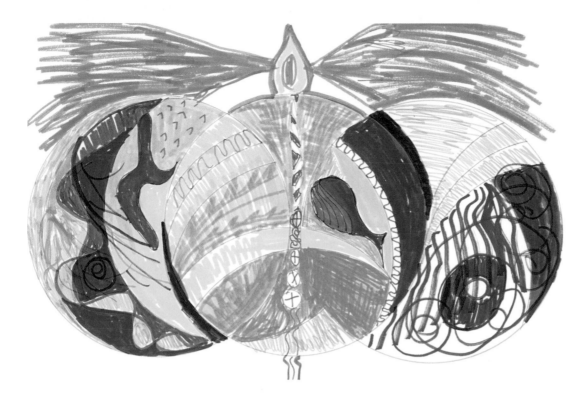

Carmen Fletcher
THE SHAMAN'S RATTLE
Mandala in markers on paper,
11 × 16" (28 × 41 cm), 1997.
Collection of the artist.

Truth does not blush.

Tertullian

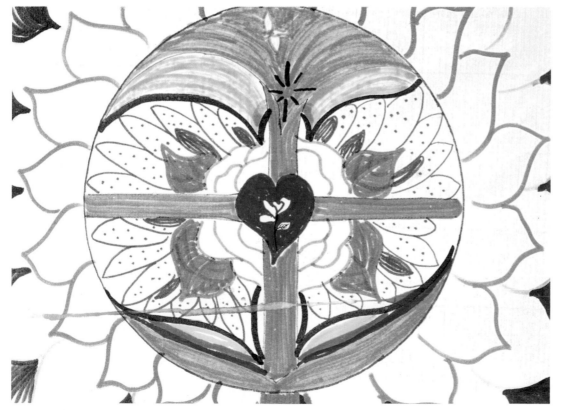

Jeanne Carbonetti
THE CRUCIBLE
Mandala in markers on paper,
8 × 11" (20 × 28 cm), 1993.
Collection of the artist.

We know the truth,
not only by the reason,
but by the heart.

Blaise Pascal

Logical Mind

The first purpose of art

is wholeness.

Peter London

Jeanne Carbonetti
POWERFUL PEONIES (DETAIL)
Watercolor on paper,
22 × 22" (56 × 56 cm), 1995.
Collection of Annie Ross.

The Practice of Mindfulness

Toward Creativity

The secret to all creative endeavor is to let the forces of your body, mind, and spirit speak to you. When you feel blocked and cannot create, it's because one of these intrinsic parts of yourself hasn't been allowed its proper voice.

One of these parts, Logical Mind, can be strengthened by honing skills of mindfulness— being fully present in the moment. As an artist, you have a natural tendency toward heightened inner awareness, so you may concern yourself too little with the external world. The Zen saying "After bliss, chop wood, carry water" expresses the importance of both inner and outer awareness.

Logical Mind is the space inside your funnel of experience that reasons and figures things out. It can zero in and focus on one piece of the pie, excluding the rest. Some artists undervalue this part of themselves as being too pedestrian to be creative. But it's Logical Mind that does the chores and is essential to the creative process because it sees what's really going on. If you reject this part of yourself, you may miss out on useful food for your spirit. In my life, I have known this too well: I easily see the cosmic picture but trip over my own feet.

As the part of our perceptive mode that is most emphasized in Western culture, Logical Mind needs to be brought into balance through mindfulness—the Zen practice of being fully in the present. When you wash dishes, be with the dishes only. Notice the feel of slippery bubbles, hear the splash of water, see the sparkle of a clean dish. Thich Nat Hanh, a Zen Buddhist monk and author of books on mindfulness, has said that one can wash a dish with the same focus as one would bring to washing the baby Buddha. This kind of awareness isn't judgmental; it doesn't draw conclusions; it doesn't react. It simply is, right now.

For the painter, mindfulness is a good exercise in concentration. It can also teach detachment, letting things go without obsessing. It's the ability to honor something—be it an itch or a grief or a deep question—by simply noticing it and allowing it to be. So many things, both inside and outside us, want to be noticed. Mindfulness gives them a chance without driving us crazy. It's a way of using mind in a receptive mode rather than actively, allowing a bigger voice to be heard than the active smaller ego that jumps to conclusions.

But it also goes deeper and wider than that. One's circle of awareness grows from the practice of mindfulness, as this little story shows. One day I arrived for my Tai Chi class early in order to practice, but found the door locked. Soon a classmate arrived, a man quite advanced in Tai Chi Chuan (ancient Chinese meditative exercises), who had the most beautiful way of fixing his attention completely on the person he was with. He always seemed to have nothing else in the world to do but talk and listen, and I found it a fulfilling experience to be with him. As we spoke, I became lost in our conversation and never noticed the janitor, who had keys to the room, go by. But my friend did, and even while giving me his full attention, he could broaden his circle of awareness and secure the keys for us. It was a fine example of mindfulness and an important learning experience for me.

Being in the moment is something that painter Zena Robinson knows very well. Looking at *Autumn Pond* (opposite) and *Sound of Leaves Falling* (see page 63), we see that Zena is a rim walker, easily disposed to hear the whispers of deeper meaning infused within all things. Her landscapes represent a view of the world that lies in the middle land of mystery. In both of these paintings, we know that we're looking at trees, water, leaves, but the artist leaves us

Zena Robinson
Autumn Pond
Watercolor on paper,
13 × 10" (33 × 25 cm), 1997.
Collection of the artist.

*I have loved the principle of
beauty in all things.*
John Keats

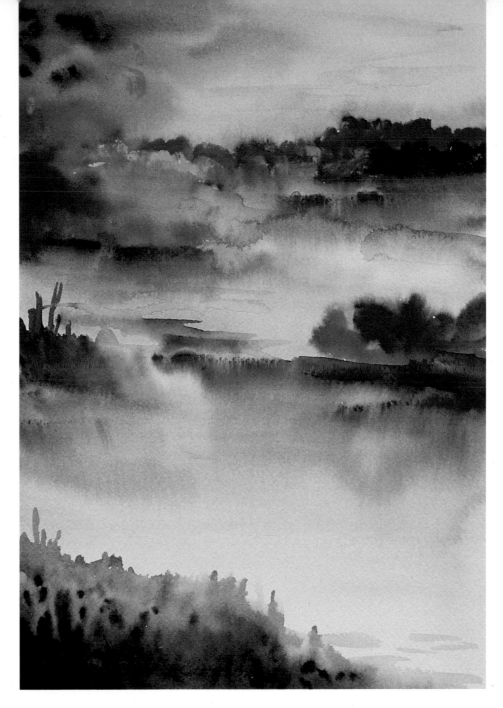

off to ponder what is beyond. These pieces represented a breakthrough for Zena. Being basically a realistic painter starting from Logical Mind, she had always used traditional color schemes. Here she manipulates color to indicate there might be more to these pictures than leaves and grass. And she pulls her misted backgrounds in just a bit closer, to make them more intimate, more introspective. Based very firmly in the here and now, her work nonetheless shows an ear that is open to the stirrings of the heart.

The Language of Form

Geraldine Stern
CITY FORMS
Watercolor on paper,
10 × 14" (25 × 36 cm), 1993.
Collection of the artist.

*There is no excellent beauty
that hath not some strangeness
in the proportion.*

Francis Bacon

All art mirrors its creator. Because of this fact, we are predisposed to resonate in certain ways to the world of form. Thus, some artists love landscapes and don't like still lifes; others paint only figures; others need all three, but at decidedly different times. Each mode tells us something different about ourselves; these choices have much more to do with what's in us than with what's out there. Learning to read forms in art helps you to pierce the mask and see the real story, the voice of your Muse calling you to your fuller vision, helping you to grow as a creative painter.

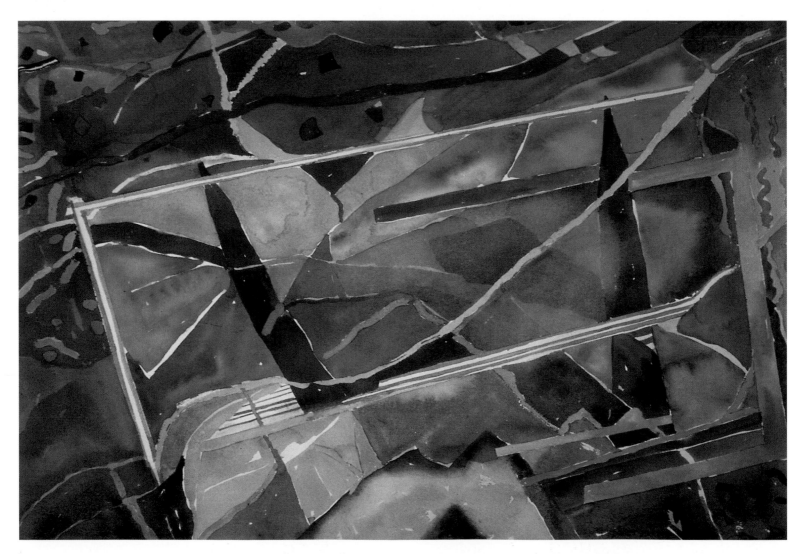

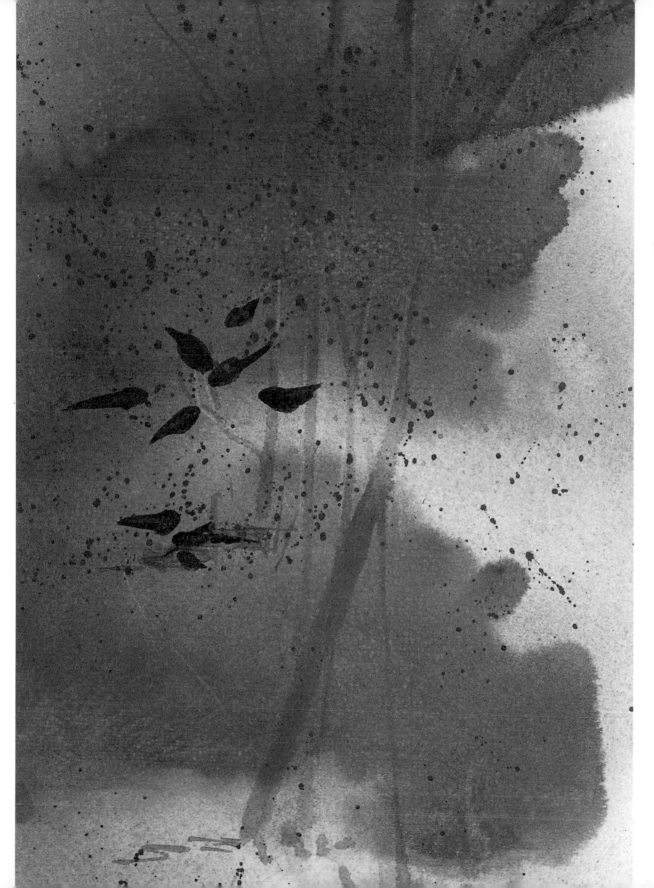

Zena Robinson
Sᴏᴜɴᴅ ᴏꜰ Lᴇᴀᴠᴇꜱ
Fᴀʟʟɪɴɢ
Watercolor on paper,
13 × 10" (33 × 25 cm),
1997. Collection of
the artist.

The music in my heart
I bore/Long after it
was heard no more.
William Wordsworth

The Art of Landscape

W hat we know comes from what we're told and from what we've experienced through our sensory data. But there are other ways of knowing that are just as valid and perhaps even more reliable. The first act of creating, then, is to know what we know, in all the ways accessible to us.

When you paint a landscape, you depict your world and how you see yourself in relation to it, where you stand most comfortably in that world. When I refer to landscape, I include all forms that reflect nature—seascapes can be a part of this large category as well as intimate gardens, and the subjects you choose bespeak important things about your personal vision. Landscapes are quite existential, for they tell how reality functions for you, how the world is from your frame of reference, and how you would like to be in it.

For some of us, the world is a very understandable place, and we come to terms with it in an orderly, sequential manner. We appreciate the details and find them quite important. For others, the world is a more mysterious place, and what is seen may speak of something unseen. For still others, the very core of things is felt and experienced rather than understood. It is the essence of things beneath the forms that is meant to be lived and breathed.

But while landscapes, as all art, reflect the artists who paint them, the special gift of the landscape form is to answer the basic question about what we know, how we see the world dancing, and how we dance with it as a partner.

For Janet Ponce, landscape art lies in the realm of the large unconscious, the world of Body Mind. Her *Fire in the Heart* (opposite) recalls the inner landscape of archetype, more than the outer landscape of reality, in its hot, molten walls of red and orange and its focus on a rock formation resembling a hand that molds a red ball within streams of light. Janet doesn't talk much about her work but when she does, she speaks about feelings. When we viewed this work together, I was quiet for some time, enjoying what I saw had happened, how some great well had been dipped into. We both just looked at this painting and then at each other and whispered, "Wow!" In her landscape art, Janet swims with power and grace in the world beyond.

Janet Ponce
FIRE IN THE HEART
Watercolor on paper, 10 × 10" (25 × 25 cm),
1997. Collection of the artist.

What is life without the radiance of love?
Friedrich von Schiller

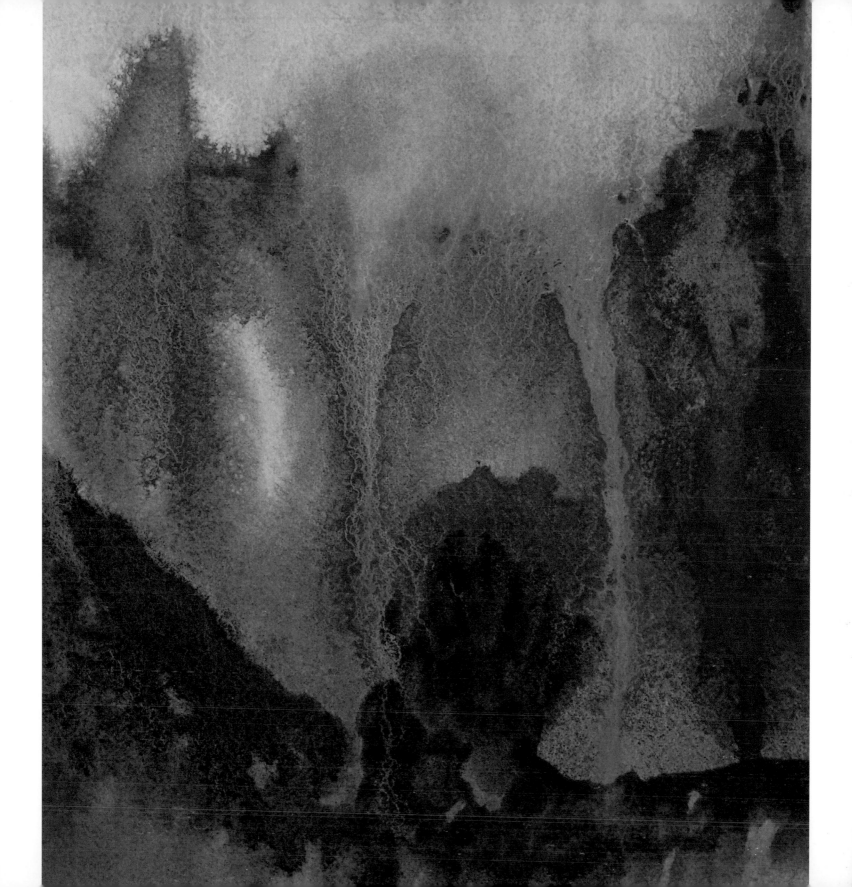

The Art of Still Life

Toward Creativity

From a Zen point of view, what you love is an essential question to ask yourself. Yet, most of us have been trained, however unintentionally, to rely on outside guidelines to tell us what we love—or rather, what we should love, or what we are allowed to love. But as a creative person, you are the true author of your personal vision, and by reading your own images and identifying how you relate to the things of your world, you'll begin to see a pattern behind the feelings that move you. The more you know about what you love, the greater your pull will be toward creativity.

Jeanne Carbonetti
Heirloom Collection
Watercolor on paper,
21 × 22" (53 × 56 cm), 1994.
Collection of the artist.

He understands who loves.

Kabir

After we ask "What do I know?" and begin sorting out our knowledge, we consider the things that affect us more personally by asking, "What do I love?" The answer lies in the art of still life. By choosing objects that we love and placing them in a certain way in a painting, we reveal our more private, interior world, which is closer and narrower in scope than a landscape.

Still life in its broadest terms means an arrangement of objects in relation to one another within a stilled moment of time. The two most important characteristics of the genre are the placement of subject matter and the quality of stillness. It's possible to include animate objects, of course, such as a cat or even a person. The famous painting by Edgar Degas of a woman next to a large pot of chrysanthemums, for example, might be categorized as a still life.

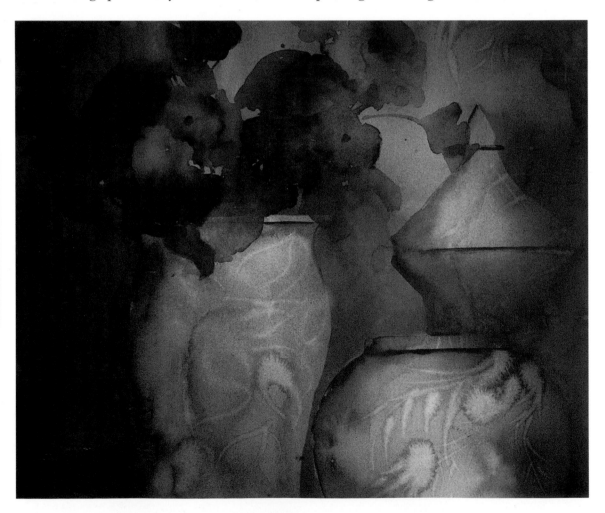

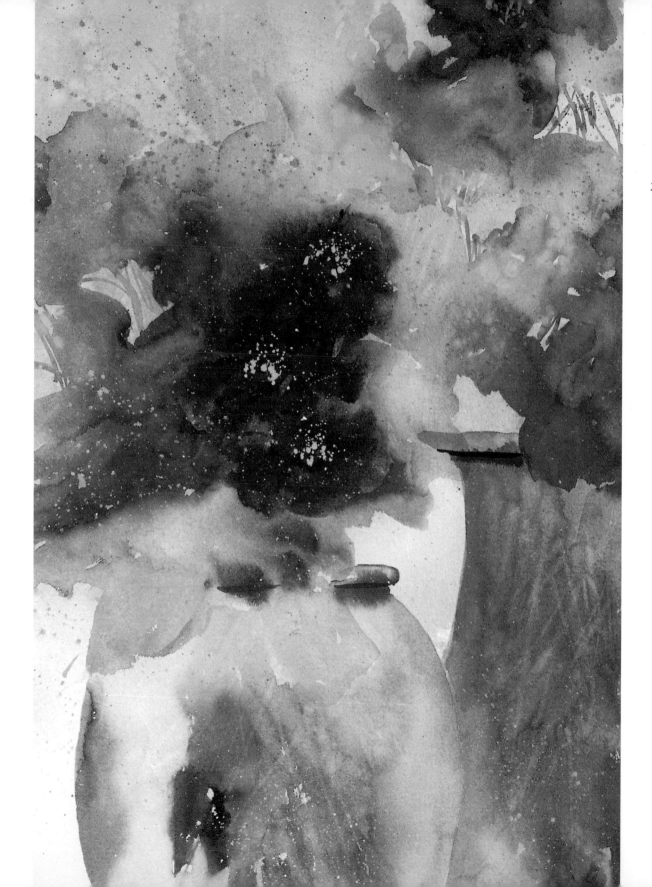

Jeanne Carbonetti
GRANDMOTHER'S FLOWERS
(DETAIL)
Watercolor on paper,
22 × 21" (56 × 53 cm), 1996.
Collection of the artist.

Trust in yourself and
everything will fall
into place.
Vedic Scriptures

A still life may be filled with lots of things, very few, or a single object. You may relish different textures or just focus on the shapeliness of things. You may zero in on your objects or allow them to breathe, leaving lots of space all around them. Your space may be clear, precise, and ordered, or it may be elusive, mysterious, floating. Perhaps it's a little of each. Whatever form your painting takes, the same principles of visual harmony that unlock the language of landscape can reveal your relationship to your world through the voice of still life.

Jeanne Carbonetti
RUTH'S FLOWERS
(DETAIL)
Watercolor on paper,
20 × 20" (51 × 51 cm),
1996. Collection of
the artist.

This Self is the
honey of all beings,
and all beings are
the honey
of this Self.
The Upanishads

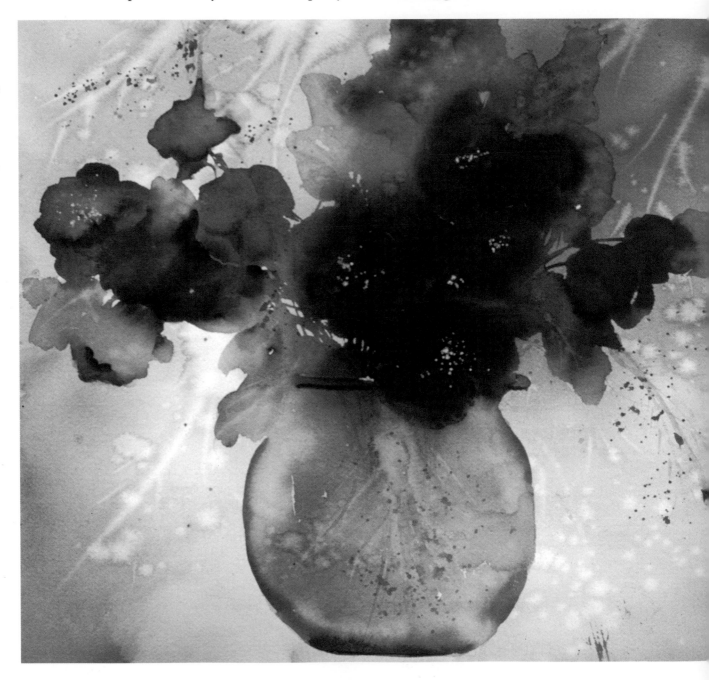

Landscape and Still Life

At this point, it would be useful to ask yourself if you have a preference for any of these major styles of art:

- Realistic (clearly recognizable subject matter)
- Impressionistic (recognizable objects, slightly manipulated)
- Symbolic, or abstract (clearly manipulated, abstracted forms of reality)
- Nonobjective (no recognizable subject matter)

Referring again to our funnel of consciousness (see page 27), where you stand on the circle of perception within that funnel has much to do with whether you wish to create realistic or abstract art. Over the years, I've discovered that those whose gift comes from Logical Mind (inside the circle) paint realistically; those who naturally work from Body Mind (outside the circle) favor abstraction; and those most in tune with Heart Mind (the rim of the circle) bend either toward impressionistic art or a symbolic, abstracted style.

Determining your niche isn't a question of which style you're able to execute; it's a matter of which you love, which you want to do. What you seek to create is what your heart jumps toward as you begin your creation, and then what it resonates with in response as you read it back again.

Carmen Fletcher
OVER THE EDGE,
ANOTHER WORLD
Watercolor on paper,
5 × 7" (13 × 18 cm), 1997.
Collection of the artist.

Landscape and Still Life

If you're a beginner, creating a mandala introduced you to the principles of visual harmony which you should now apply to landscapes and still lifes. For intermediate painters or creators in other fields, working on landscape and still life will help you become more conscious of the way you craft your art, allowing yourself to look to your Muse with different eyes so that your full expression may emerge. If you're an advanced painter, the following work will help you go to a new, deeper level of awareness of the gift you wish to give to the world.

The five concerns covered here—scanning, gathering inspiration, envisioning, choosing a medium, and playing with your image—apply to both landscape and still life, and in the next chapter, to figure art as well.

Scanning

Go quickly through a book of master paintings, scanning to find your preferences. Don't judge quality; that is the reason for using master works. The question is rather how you respond to them. Note the ones you like and the ones you don't like. Using the six principles of visual harmony—story, focus, composition, value, color, texture—can you explain why? These key words are catalysts for translating your impressions. You may wish to be kinesthetic about it, so it's OK to express your gut reaction through movement or dance (your Body Mind instinct).

Gathering Inspiration

Do whatever feels most natural to gather images for use in your paintings: Review travel photos of places you've enjoyed visiting; look out windows right now for favorite landscape vignettes, and inside your home for treasured objects; go through books and magazines. As you seek images for your landscape, do you notice preferred patterns? Are you attracted to the tall verticals of tree trunks or the repetition of curved hillsides? For your still life, does the texture of drapery or the glow of silver candlesticks draw your attention? Do lush floral colors stop your eye? Those are clues to subject matter that will inspire your paintings. Sometimes, as in *To Every Season* (opposite), inspiration from several sources will inform a single painting.

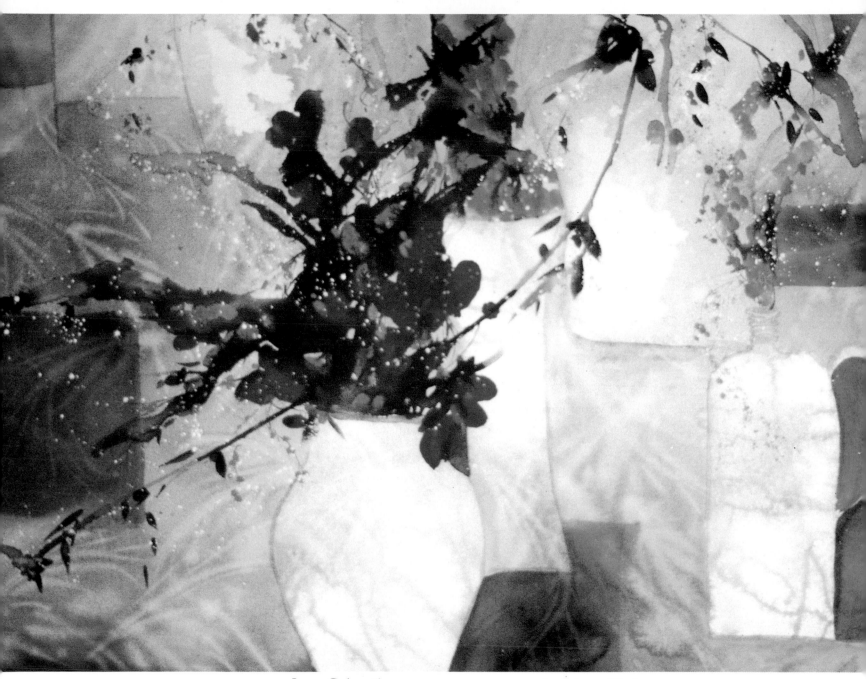

Jeanne Carbonetti
To Every Season
Watercolor on paper, 22 × 30" (56 × 76 cm), 1993.
Collection of Victoria and George McGinty.

Art is long; life short.

Johann Wolfgang von Goethe

71

Envisioning

Ask yourself if you'd like your picture to be realistic, impressionistic, symbolic/abstract, or nonobjective. If you're a beginning artist thinking, "I'd love to paint an Andrew Wyeth barn, but I know I can't," don't deny your Muse. Let her guide you toward your need, in that realistic direction calling you. On the other hand, if you're intrigued by the shifting planes and forms of abstracted reality, as in Geraldine Stern's *Picasso's Vases* (opposite), follow your Muse, as she did, down that path.

If you don't know yet which style is yours, or if you change your mind about it, that's OK, too. But try this little experiment: Think the words *still life* or *landscape,* close your eyes for a moment, and see what images form. As subtle as this seems, it will help, for it's your Muse speaking her intention to guide your artistic hand.

Choosing a Medium

No matter what style of expression your art follows, the medium you use will impact on the images you make. Here are the characteristics of each to consider:

- Watercolor: transparent, flows easily, dries quickly.
- Oil: produces thick textures, more fluid when diluted; dries slowly, allows playing time.
- Acrylic: can be used thick or thin; not as transparent as watercolor, but dries quickly.
- Pastel: oil or chalk, used for both drawing or painterly effects.
- Markers: quick drying, easily portable, opaque or transparent effects.
- Colored pencils: easily portable, dry medium.
- Collage: pieces of plain or patterned paper or other material glued to a surface, often combined with paint or other mediums.

Playing with Your Image

When painting landscape or still life, work from instinct and intuition, just as you did when creating your mandala. Let your image unfold, rather than trying to force it. Principles of visual harmony will help you respond if you don't know what to do next. If you're a beginner who wishes to try something traditionally realistic, your goal should be allowing your vision to be revealed first; learning the skills you need comes later. This approach is the reverse of most traditional art training in Western culture, but I believe it's what aids total growth in the end because it's more natural, and it works with the force of your motivation.

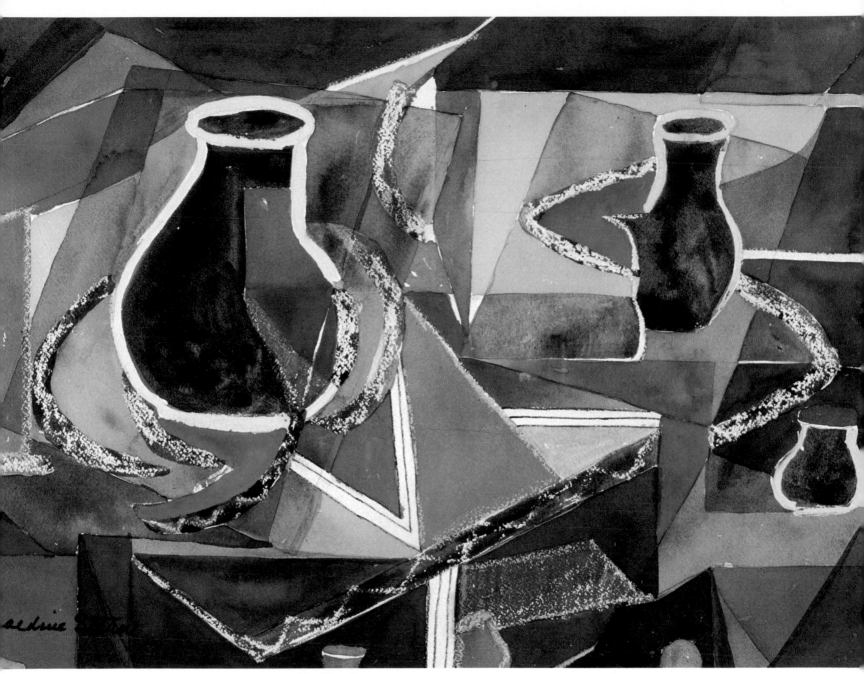

Geraldine Stern
Picasso's Vases
Watercolor on paper,
15 × 22" (38 × 56 cm), 1993.
Collection of the artist.

*There is but one history
and that is the soul's.*

William Butler Yeats

Notes About Drawing

Toward Creativity

If you're untrained in drawing, first allow yourself time to feel your subject, literally, before drawing it. To understand the shapeliness of the vase you want in your still life, before sketching it, pick up that vase and run your hand over it; feel its pudginess, its roundness, its length, where it narrows or widens. If your still life includes flowers, hold one gently and stroke each petal, noting its length, shape, how each petal grows from the flower's core. Feel the center. Is it big and puffy? Hard? Textured? Are there sections to it, such as a core with a ring of dots? This process is not only an eye-opening experience; it's enjoyable, relaxing, meditative, and sharpens concentration, which is an essential drawing tool.

Tracing paper provides practical help with drawing. I don't mean tracing directly, so don't worry about "cheating." This is actually a variation of classical drawing instruction in which students work from master drawings first to learn how reality is translated into line. For example, if you're drawing a flower, put it on your tracing paper and run your pencil around it. Or if you're working from a drawing or photo, trace the boldest lines; it will train you to see shapes and space more clearly. This very action will begin to bring your eye and hand together, honing your drawing skills. It will also provide lines and shapes that you can manipulate into a pleasing composition on your paper or canvas.

The key thing to remember is not to be stymied by your concern for drawing technique. I've seen many wonderful creators with powerful potential stop before they ever got started because of this obstacle. Particularly for those with more symbolic and abstract visions, the dilemma can be quite paralyzing. The heart of their communication calls for the opposite of realistic drawing, yet they feel obliged to render precise drawings first, as if they need to establish "academic" credentials before following natural creative impulses in another direction. Unfortunately, what often happens is that their Muse retreats, and they remain mute and frustrated.

By keeping your drawing simple, just getting something down relatively quickly, you'll allow yourself to see the kind of vision you really have. The tools of your vision, drawing being one of them, will fall into place as they are needed. Your own Muse will be your guide.

Acknowledging Your Work

In the drawing stage and when developing your piece into a painting, back up often to view your work from a distance. What you judge as "bad" close up may be good seen from farther away. But if something is awry, love it, and yourself, for trying. Good things take time and sometimes lots of tries. Have patience. Act like a scientist, just look to see what happens; don't try to force it. Every mark you make will tell you something, will guide you to the treasure that is your true self.

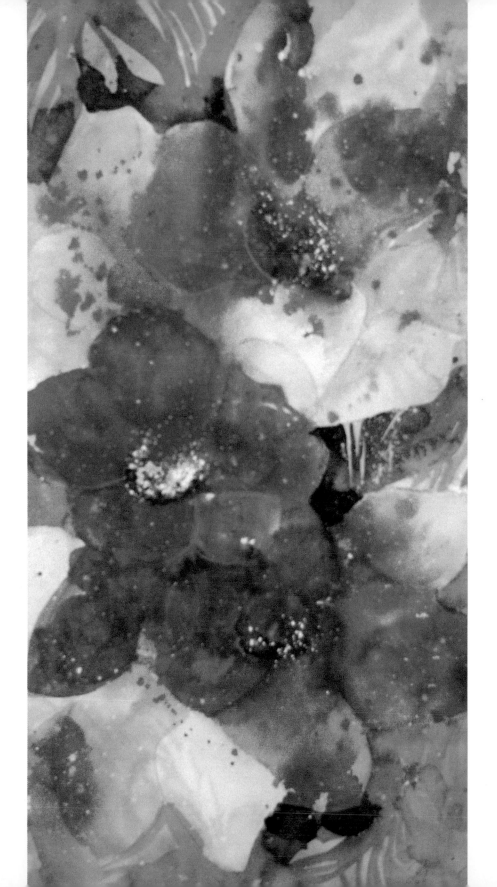

Jeanne Carbonetti
Vishnu's Flowers
Watercolor on paper,
30 × 14" (76 × 36 cm), 1994.
Collection of the artist.

Much learning does not
teach understanding.

Heraclitus

Observing other artists' work is equally helpful. Look at how Ann Kellogg plays with space and shapes in *Bell, Book, and Candle* (opposite), while utilizing quite recognizable objects. Her story is not so much about the objects of focus as what they lead to. Ann uses colorful edges to veil the clarity of her bell, book, and candle, and to suggest to the viewer that all is not only what one sees.

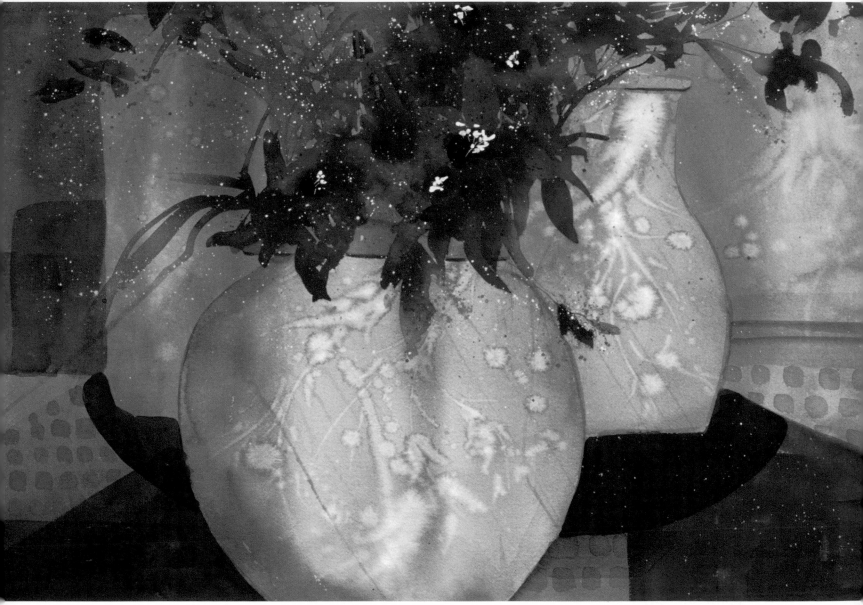

Jeanne Carbonetti
STILL LIFE WITH TIGER LILIES
Watercolor on paper, 22 × 30" (56 × 76 cm),
1996. Collection of the artist.

Do not fear mistakes.
There are none.
Miles Davis

Ann Kellogg
BELL, BOOK, AND
CANDLE
Watercolor on paper,
22 × 15" (56 × 38 cm),
1997. Collection of
the artist.

*It is not because
things are difficult
that we do not
dare; it is because
we do not dare
that things are
difficult.*
Seneca

Landscape Art

Toward Creativity

When you've finished a landscape painting, look at it from a distance. It's best to put a white mat around it. If you keep two pieces of three-inch mat on hand, you can adjust them to fit any size painting. But if a mat isn't readily available, place sheets of white paper along the edges to give your painting the semblance of a frame and set it off from its environment for your viewing.

Your landscape painting should be read just as you read your mandala. Again, practice by exploring work by other artists, as well. For example, looking at *The Harbor* (opposite), what story does Geraldine Stern's painting convey to you upon first impression? Do you see a singular focus, or is this a travel picture, taking you from place to place? In terms of composition, is it quite frontal, up close, or floating? Is foreground, middle distance, or deep distance strongest? Is there a decided vertical, horizontal, or diagonal thrust to the piece? What are the major divisions in space?

When I first saw Gerry's realistic paintings many years ago, there was a strong sense of geometry that often overpowered her work and quite dismayed her. She wanted to get rid of "that terrible habit." But I heard the voice of her powerful Muse expressing the need to translate concrete forms into abstracted ones. Gerry's flowering sprang from finding the appropriate sequence for being realistic, being abstract. Even though she would base her paintings on things she saw and noted in her sketchbook, when she began painting, she would concern herself more with geometric forms that had distilled in her memory. The process became more playing with abstract forms than depicting a "real" place, but she always ended by relating both, and in a way that finally pleased her. A realistic painting, though beautifully rendered, would bore her. Likewise, an abstract that was all flow with no edges left her unsatisfied. By weaving different planes, moving in and out, around and through, Gerry has presented on paper the heart of her unique vision.

The work of acrylic painter Janet Fredericks is so seductive, it calls the viewer to enter and be enveloped by her space, particularly in her series of boat paintings—*Ascending Rope* (see page 80), and one shown in the next chapter (see page 100). Although the world of matter is clearly present in Janet's work, it's a world that quietly builds itself out of the stuff of spirit, like a vision in a fog. She begins with studies of images she sees around her, then draws and redraws, which helps her penetrate the core of the subject until she arrives at its true nature. Her chosen medium of acrylics gives her time to feel her way, sometimes with layers of impasto that build to a flourish, enfolding us in their rhythms.

For John McNally, lawyer and artist, painting is not a hobby, but rather a vital way of balancing his life. He is exquisitely aware that having both Logical Mind and Body Mind equally strong is a key to the dynamic balance that makes both lawyer and artist function creatively and with power. A reading of his landscape paintings (see page 81) will show you what I mean.

Geraldine Stern
The Harbor
Watercolor on paper, 15 × 22" (38 × 56 cm),
1991. Collection of the artist.

*Individuality of expression is the
beginning and end of all art.*
Johann Wolfgang von Goethe

Look at how John loves color for the sake of color and texture for the sake of texture, making juicy, evocative strokes of deliberate boldness. With oil paint he uses the medium to express his more exotic side and to stretch his ability to get at the heart of things. In *Sophia Street,* the essential shapeliness of the scene is the true story; in *Zea's Farm,* bold watercolor, clearly manipulated, reinforces his personal rendition of a place over its clinical reality; in *Sky, Mountains, Field,* he works directly from nature, but it's clear that there is a pull in opposite directions— what's out there and what's inside of him—the dynamic that produces his unique vision.

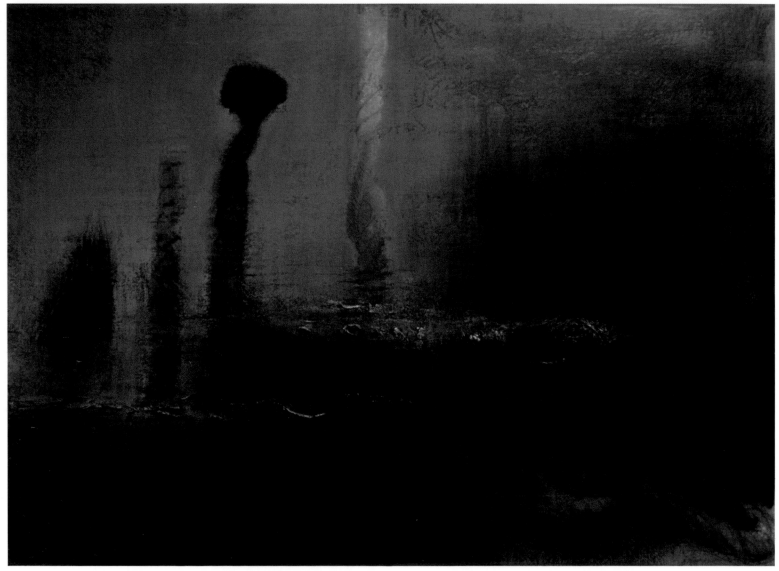

Janet Fredericks
ASCENDING ROPE
Acrylic and fiber on canvas, 39 × 51" (99 × 130 cm),
1997. Collection of the artist.

Work is love made visible.
Kahlil Gibran

John McNally
SOPHIA STREET, FREDERICKSBURG
Oil on canvas,
9 × 12" (23 × 31 cm), 1997.
Collection of the artist.

*The final approval
has to come from ourselves.*
Dennis Genpo Merzel

John McNally
ZEA'S FARM
Watercolor on paper,
10 × 14" (25 × 36 cm), 1997.
Collection of the artist.

*The great man is he who does
not lose his child's heart.*
Mencius

John McNally
SKY, MOUNTAINS, FIELD
Oil on paper,
18 × 24" (46 × 61 cm), 1997.
Collection of the artist.

*The more the marble wastes,
the more the statue grows.*
Michelangelo

Toward Creativity

Recognize your particular stance as an artist and believe in it. I've had students whose proclivity is decidedly toward abstract art, but they won't work that way for fear that someone will say, "Any five-year-old could do that." If such thoughts prevent you from granting yourself permission to work abstractly, please know that the difference between children's art and mature abstraction is vast. Even when adults work from the larger unconscious, they paint with an intention that is missing in children's art because, charming as it is, a child's art only expresses, whereas adult art communicates. As an adult artist, you can use and manipulate the principles of visual harmony in deliberate ways to focus your story, even when it's told abstractly.

Art cannot lie. It's always a picture of its creator, as the following still lifes by different artists show. Like our unique signature, we each have a certain way of combining the elements of our world.

Of the pieces shown on the next few pages, *Japanese Vases* (opposite) by Carmen Fletcher is the most traditionally realistic. The objects and spaces around them aren't manipulated in a dramatic way, yet they have Carmen's imprint, created primarily through color and composition. The vases draw close to us as they sit on the mauve tabletop, but of nearly equal weight is the blank, bright yellow background occupying nearly half of the painting. Using yellow and mauve complementaries makes a powerful color and compositional statement, and observe how much Carmen loves the lushness and textures of individual objects, each one its own Zen moment, with her negative space just as textured and full.

Janet Ponce actually began *Genie's Lamp* (opposite) as a landscape, then it took off from there and became this intriguing still life. I'm particularly fascinated by the way her magic lamp seems to be opening up to let her heart out. Cool in color, it sits on some kind of platform, while behind it is a world ablaze with warm hues and interesting shapes swirling all around.

Rita Malone's work, while being primarily abstract, refers to forms that are symbolic and metaphoric rather than concrete and real. Rita was pulled by little gremlin voices that told her she wasn't an authentic artist unless she painted realistically. Yet whenever she tried to do so, she didn't enjoy the process and was never pleased with the result. Being adept at monitoring her own work, Rita become aware that her body signaled to her feelings of being "in flow" whenever she worked abstractly, and signaled "up tight" whenever she tried to paint realistically. Little by little, she came to accept that her artistic voice resided between the two.

With *Triumph of Icarus* (see page 84), *Music of the Deep* (see page 85), and *The Great Fish* (see page 85), the transition became complete. In these powerful pieces, she not only accomplished her own journey to her Muse, but she saw that pure abstraction had the ability and power to say what she most wanted to share, that the great beauty of life is its movement, its process.

There is one overriding principle that is fundamental to creating with power: Whatever you are naturally is what you should be. Allow yourself to trust it.

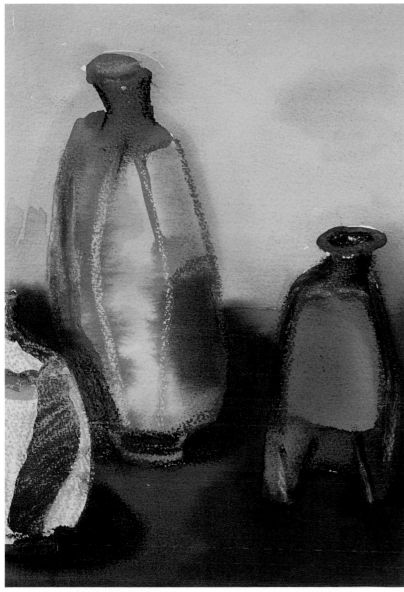

Carmen Fletcher
JAPANESE VASES
Watercolor on paper,
13 × 10" (33 × 25 cm), 1996.
Collection of the artist.

*There it is and you have
made it and have felt it
but it has come itself.*

Gertrude Stein

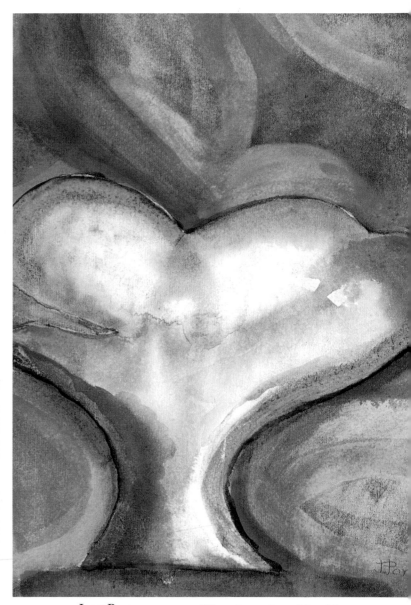

Janet Ponce
GENIE'S LAMP
Watercolor on paper,
18 × 12" (46 × 31 cm), 1997.
Collection of the artist.

*Thou hast given him his
heart's desire.*

Psalms 21:2

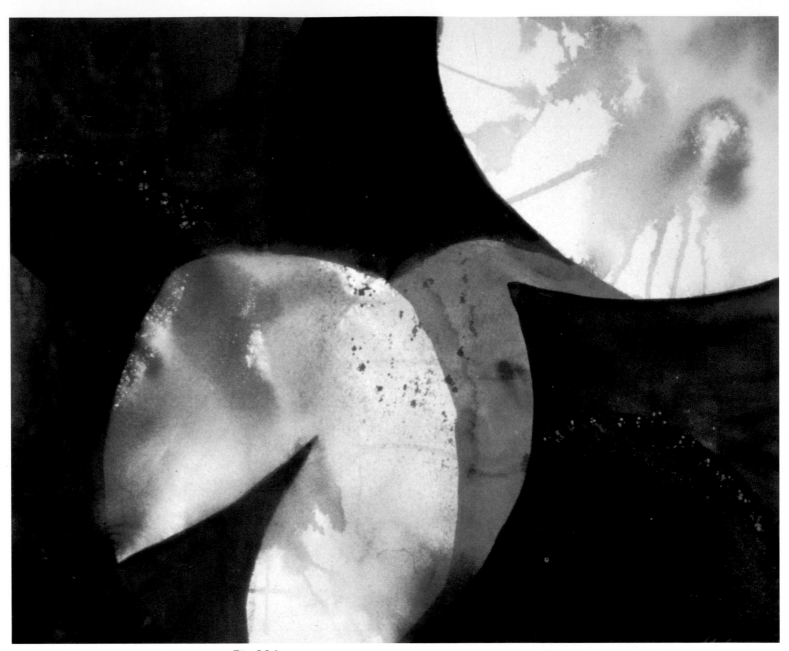

Rita Malone
Triumph of Icarus
Watercolor on paper, 20 × 20" (51 × 51 cm),
1995. Collection of the artist.

We must become that moment,
make ourselves
a sensitive recording plate.

Paul Cézanne

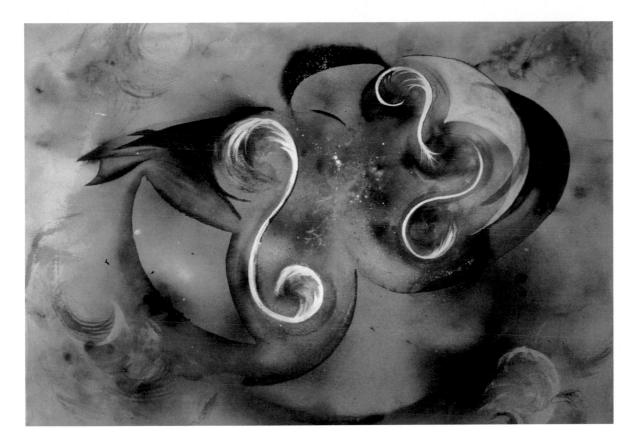

Rita Malone
Music of the Deep
Watercolor and ink on paper,
15 × 22" (38 × 56 cm), 1995.
Collection of the artist.

*Pipe me to pastures
still and be/The music
that I care to hear.*
Gerard Manley Hopkins

Rita Malone
The Great Fish
Watercolor on paper,
15x 22" (38 × 56 cm), 1995.
Collection of the artist.

*Mirrors should
reflect a little before
throwing back images.*
Jean Cocteau

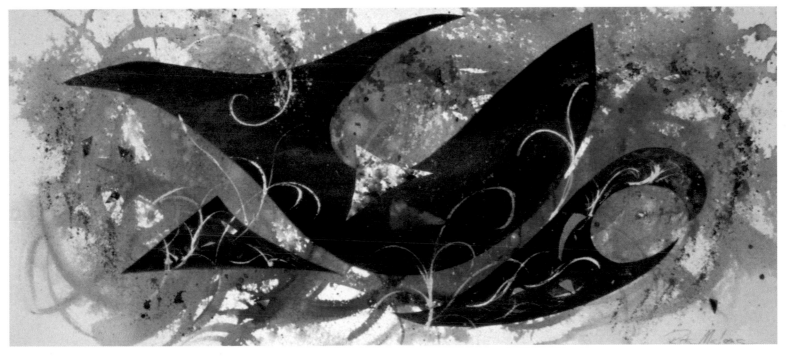

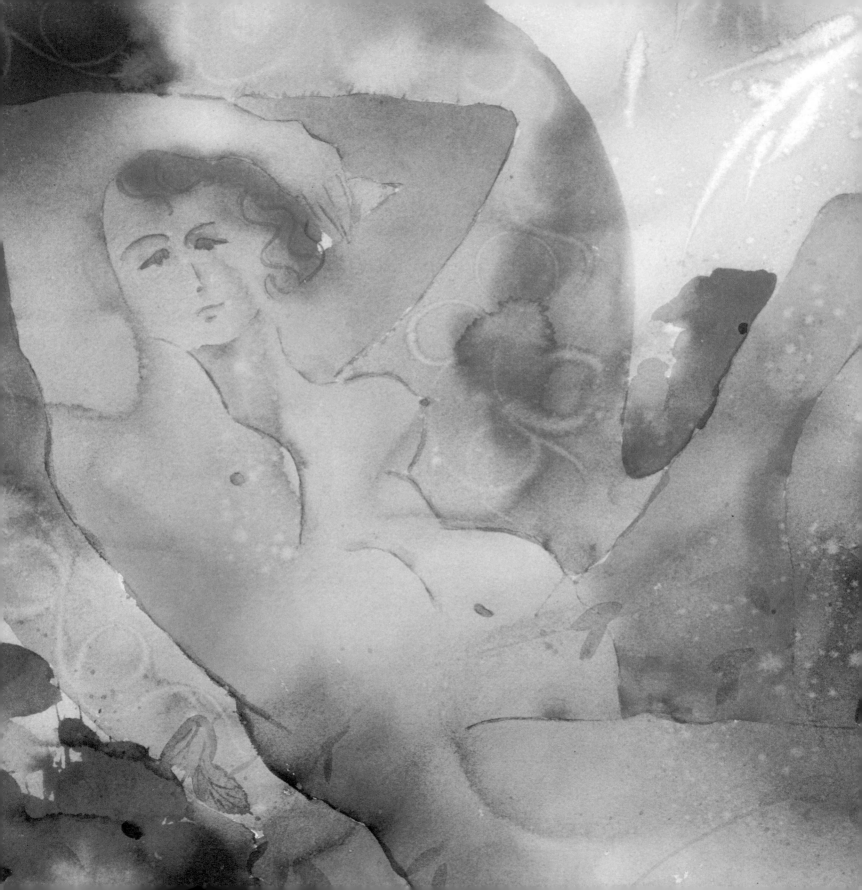

Heart
Mind

What the inner voice says

will not disappoint

the hoping soul.

Friedrich von Schiller

Jeanne Carbonetti
MATISSE'S LADY
Watercolor on paper,
22 × 28" (56 × 71 cm), 1997.
Collection of the artist.

The World of *Intuition*

Toward Creativity

A popular way of getting in touch with the intuitive voice of Heart Mind, "journaling" is an exercise that connects you with words and thoughts beneath the surface of your focused consciousness. When I practice journaling, I'm often amazed to discover what's really going on in my heart.

Try this test. Simply commit to paper, as quickly as possible, whatever is in your thoughts. Use pencil, typewriter, or computer—whichever tool keeps up best with your rapid flow of words. After only a few paragraphs, you'll see your surface thoughts falling away as larger issues and truer perceptions push their way ahead, opening doors to allow Heart Mind its creative say.

eart Mind synthesizes the world of Logical Mind and Body Mind. It sees both sides at once, head and gut, and seeks an answer to address each, concentrating the power of your knowledge and passion into the exquisite stroke of clarity that is a *choosing*. Since neither the first stage of being in Body Mind nor the second stage in Logical Mind is equipped to make choices, decision-making falls to the province of Heart Mind, because it alone has access to both worlds simultaneously. The gift of Heart Mind is that when it issues answers, you know they are right because things feel so very good. You sense an epiphany occurring. An awakening *Aha!* confirms that you are whole, one in body,

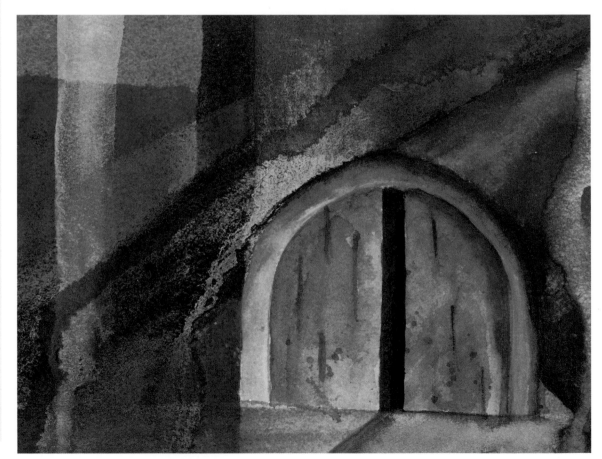

Janet Ponce
Doorway to Myself
Watercolor on paper,
12 × 15" (31 × 38 cm), 1997.
Collection of the artist.

Love, love, love,
that is the soul of genius.
Wolfgang Amadeus Mozart

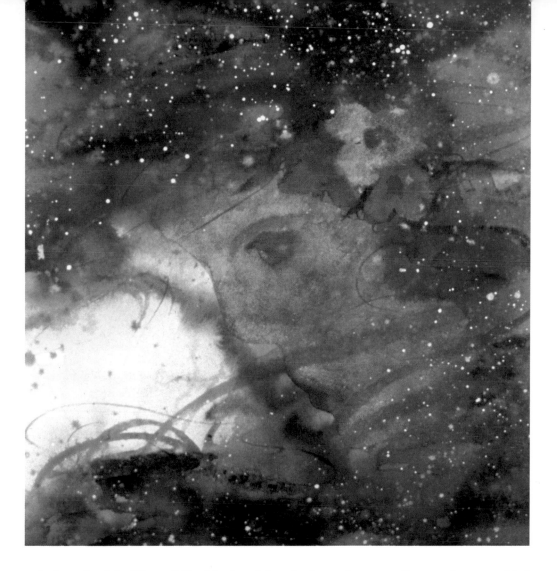

Jeanne Carbonetti
Persephone (detail)
Watercolor on paper,
24 × 22" (61 × 53 cm), 1989.
Collection of the artist.

If I had only two pence,
I would spend one on food,
the other for a lily.
Kahil Gibran

mind, and spirit. Heart Mind is the alchemical vat that transforms what you think and feel into what you understand. It's the world of intuition reaching you through your inner sight (insight). Psychologists call this the subconscious, the place that reconciles the iceberg tip of your focused consciousness with the vast iceberg of your unconscious.

When Heart Mind reveals an answer that satisfies, it does so in that unique gesture of will that marks the human being as cocreator in the universe. We say as we were designed to say, "Let there be . . . this!" Heart Mind does so by *waiting*. It incubates, holding all parts together patiently. This is not easy in our American culture, for we try to jump the gun, creatively. We develop such a momentum from our research-and-development stage, at which we excel, that we don't want to slow down and wait for an answer; we want it *now*, and too often we force it, deciding with either Logical Mind or Body Mind and not choosing with Heart Mind. But if we remember the old adage that love is always the answer, and if we wait and are patient with Heart Mind, creatively speaking, it is always the only answer.

Toward Creativity

Visualization is another good way to be in touch with Heart Mind. In this exercise, picture a given situation and direct the activity, much as a director would guide actors in a play. But visualization has a subconscious as well as a conscious component. Picture a bench, for example (conscious direction), then wait to see who comes to sit on it (subconscious reception). Imagine other settings and see what else unfolds. Visualization has both active and receptive sides that can be very powerful for gaining self-knowledge and even for healing. For me, personally, visualization exercises were a vital aid in my own journey through rheumatoid arthritis, opening up beautiful paths that allowed inner wisdom to come to me.

What brings us to T. S. Eliot's "still point of the turning world . . . where there is only the dance"? How do we go down that deep, without getting stopped or stuck?

I've noticed that three fundamental abilities belong to creative achievers, and they seem to come in a certain cumulative order, each dependent on the one before for its accelerated power. Together, like the force of gravity, they pull the creative potential of your life force with greater and greater power down through the funnel of experience and filter of love, where it truly becomes your own. These three abilities are nonjudgment, playfulness, and imagination. Creation isn't possible without them.

Nonjudgment

The first energetic pull toward creativity is the most intrinsic to getting a hold on what you really love. Without nonjudgment, life falls into the top of the funnel and gets stuck there, like autumn leaves clogging up a rain gutter. It's one thing to know about life, but it's another matter to do something with your knowledge by refining it, like flour through a sieve, to clarify what you love within your world. By identifying what you love, you're moved to form it into something that expresses that love. But if you start judging things too soon, creativity gets stopped before it ever gets going. Unfortunately, we're often taught that criticizing ourselves is morally superior to accepting ourselves, which is called narcissistic and vain. We're told that there's always room for improvement, that we shouldn't rest on our laurels. Such thinking produces perfectionists who give themselves no peace.

Not that it isn't worthwhile to be diligent. We've just learned our lesson too well. But that's how the creative process works—opposites experienced, then synthesis. We just need to experience more of our yin nature now, the side that accepts ourselves, allows our experiments. Let's be kinder to ourselves and not worry about becoming sloppy or lazy. We won't lose our edge, but we will soften its corners so that life flows more smoothly through us.

Patience is integral to nonjudgment. I often see students start to fix things so early in a painting that it and they look tired before it's half done. Many such "problems" are the very things that animate a painting. When the dynamic balance of a piece swings in a particular direction, all that's needed is a response to the new direction. Recently, a student began to scrub out a strong value in a floral painting. In the spirit of experimentation, I asked her to trust to my discernment and not worry about those values until later. Her finished painting was a glory—clean, clear, deliberate. I asked why she thought it turned out so well. Of course she knew. It was the strength of those values, which she had judged as wrong, that gave power and life to her painting.

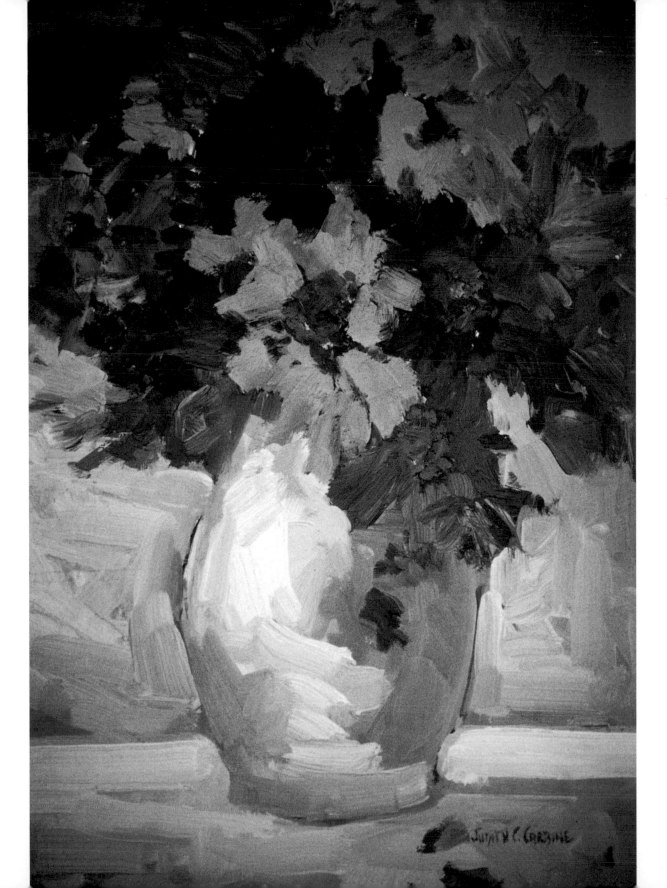

Judith Carbine
FARMERS' MARKET
SUNFLOWERS
Oil on paper,
14 × 11" (36 × 28 cm),
1997. Private collection.

*The thirst after
happiness is never
extinguished in the
heart of man.*
Jean-Jacques Rousseau

Judith Carbine
FOLIAGE IN ANDOVER
Oil on paper, 14 × 11" (36 × 28 cm), 1997.
Private collection.

A work of art is a corner of creation
seen through a temperament.
Émile Zola

Patience can take you a long way. From my beloved Rejection Drawer have come so many paintings that later became my favorites (they were just waiting for me to know how to respond) that I now call it my Resurrection Drawer. Sometimes, it just takes time and trust that you will be able to get the image you're after, even if it's not today.

Patience is a quality that exemplifies the paintings of Judith Carbine. In *Farmers' Market Sunflowers* (see page 91), *Foliage in Andover* (opposite), and *Mendon Mountain Orchard* (below), Judy's world exists not only for itself but for others. It's a world of relationship, where every cottage, every tree, every blossom is an intrinsic piece of a harmonious whole. Her forms are near enough to be real, yet far away enough that she can play with and merge their edges. For Judy, the whole is more than the sum of the parts, and it's this feature of her work that presents to the viewer a sincere expression of peacefulness.

Judith Carbine
MENDON MOUNTAIN ORCHARD
Oil on canvas,
24 × 30" (61 × 76 cm), 1994.
Collection of Sandra and
Thomas Morton.

*To err is human,
to forgive divine.*
Alexander Pope

A third quality of nonjudgment is persistence, trying again. I've done many paintings six or seven times to get just the nuance I'm after. I don't consider the first tries as errors. Quite the contrary, they're all part of the puzzle, each piece telling me what's needed to complete the feeling I want to have for the painting to speak to me. If I'm willing to be nonjudgmental, their voices will always be clear. With patience, trust and persistence, I'll be able to break through the barriers of "I should" and uncover my true voice saying, "This is what I choose."

Jeanne Carbonetti
CHOOSE
Watercolor on paper, 22 × 30" (56 × 76 cm),
1991. Collection of the artist.

*Without this playing with fantasy
no creative work has ever yet
come to birth.*
Carl Jung

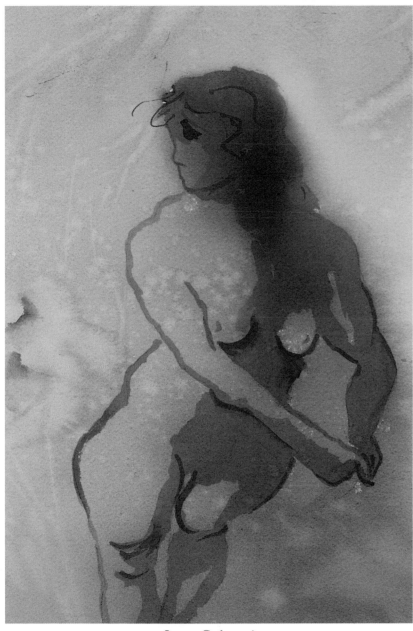

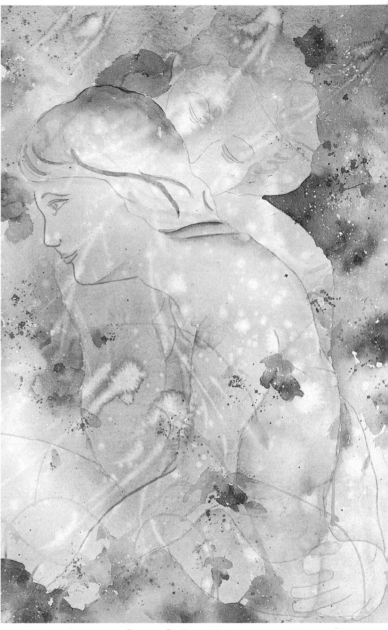

Jeanne Carbonetti
Psyche Waiting
Watercolor on paper, 16 × 12" (41 × 31 cm), 1996.
Collection of the artist.

A man of genius makes no mistakes.
His errors are volitional and are the portals of discovery.

James Joyce

Jeanne Carbonetti
Twin Flame
Watercolor on paper, 26 × 20" (66 × 51 cm), 1996.
Collection of the artist.

Works of art are indeed always products of having been
in danger, of having gone to the very end of experience,
to where man can go no further.

Rainer Maria Rilke

Playfulness

The next powerful ingredient of creative painting is playfulness, a spirit that is undervalued and often misunderstood, yet is essential for discovering what you love enough to choose. As an artist, I take play very seriously. If I didn't play with ideas and with paints, I would never create anything.

Playfulness is the ability to be with something for its own sake, for the curiosity of learning more about it, without a fixed end in mind. One of the most obvious characteristics of works by Matisse and Picasso, perhaps the two consummate creators of the twentieth century, was their ability to be playful with mediums of all kinds. When artists are most playful, they are closest to pure scientists, for both must be willing to allow whatever happens, to happen. True art and true science are much closer than people think. Einstein said he never would have come up with $E = mc^2$ if he had not been able to play with an idea.

Playfulness implies risking mistakes. As a painter, you need to be free to make mistakes— big, ugly errors and messes, for they are the stuff from which vibrant learning emerges. One trait above all others tells me right away if a student will become a dedicated artist: the willingness to go for the big mistake. The painter who doesn't know how a color will look over there and tries it to find out, will go on to try more and more ways to say things, and in the end will find original forms of self-expression. The student who plays it safe and wants assurance that a painting won't be harmed won't have the fortitude to go deeper and grow as an artist. I promise, you're a better painter tomorrow for having made a mess today. When you're at your worst, you are becoming your best.

When you think you're at your worst, your creative voice, like the child learning to walk, needs to know it's OK to fall. With playfulness goes the spirit of forgiveness—letting go of preconceived notions of how something should turn out. The creative process is the constant interplay of artist and medium in dialogue. When your paint throws you something surprising, it's up to you to respond to it freely, not to force a result. There's a world of difference between forcing a form that you're *supposed* to love, and creating one that answers "What do I *really* love?"

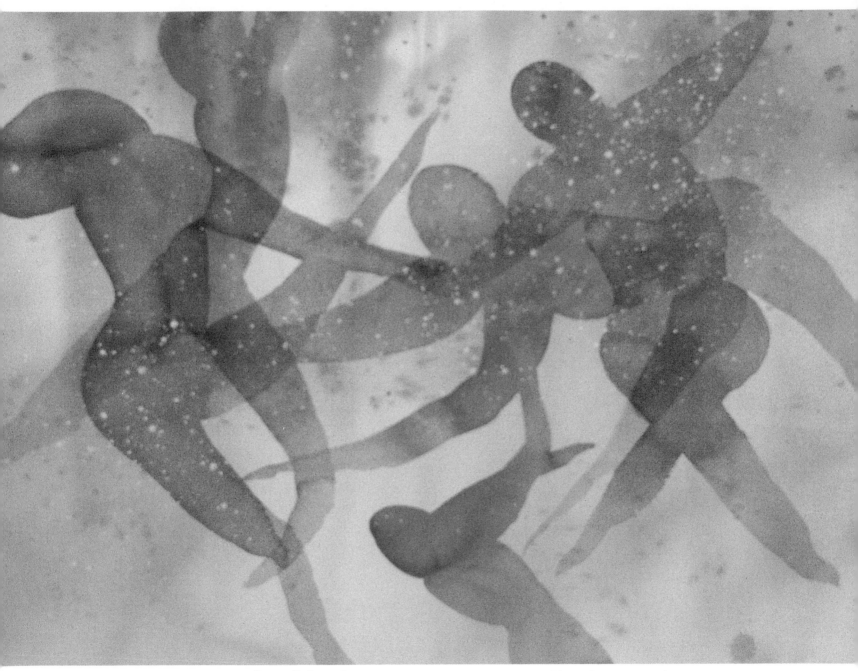

Jeanne Carbonetti
LET THE CHILDREN DANCE AND SING
Watercolor on paper, 22 × 30" (56 × 76 cm),
1991. Private collection, Vermont.

When you do the things that you can do,
you will find the way.
A. A. Milne

Jeanne Carbonetti
UNFORBIDDEN
FRUIT
Watercolor on
paper, 30 × 22"
(76 × 56 cm),
1991. Collection
of the artist.

*There is in the
creator a deep
longing to
create. This is
not ego in the
popular sense,
but purpose in
the higher sense.*
Robert Fritz

Carmen Fletcher
PINES
Watercolor on paper,
11 × 7" (28 × 18 cm), 1997.
Collection of the artist.

*Be really whole,
and all things
will come to you.*
Lao-tzu

Imagination

The most powerful creative life force is undoubtedly imagination. But until you're non-judgmental with yourself, and playful, you can't be imaginative and exercise your ability to envision. I see a strong correlation between knowing what you love and being able to imagine, and I think it works both ways. People who spend time in acts of imagination find it easier to know what they really love. People who know what they love can spend time imagining it.

I don't necessarily mean that you must see a concrete picture in your head to paint it. Images can be triggered in many ways—with words, sounds, symbols, music, feelings, or sense perceptions such as the warm feeling of a hug. I personally like to include visual, verbal, and kinesthetic cues in my acts of imagination. But there is one crucial component to imagination: the willingness to be *outrageous*. Yes, outrageous. Even the word makes some people recoil. But to be fully creative means being fully yourself, and to be perfectly frank, at some point or other, your uniqueness may seem outrageous to some.

Janet Fredericks
AGROUND
Acrylic on canvas,
45 × 57" (115 × 145 cm), 1996.
Collection of the artist.

*What if imagination and art
are not frosting at all,
but the fountainhead of
human experience?*
Rollo May

Harry Dayton
WATERFRONT
Watercolor on paper,
15 × 22" (38 × 56 cm), 1997.
Collection of the artist.

*I find that I have
painted my life—things
happening in my life—
without knowing.*
Georgia O'Keeffe

One of my favorite examples of outrageous expression has to do with a house that I saw a few years ago when my husband and I were driving my mother back to her native Mississippi. As we rode past a poor section of one town that had identical, drab little bungalows, one house stood out like a beacon. It was painted bright canary yellow with emerald green shutters. My first impression was to smile and wonder what the neighbors thought about that house and its occupants. But as we drove on, my heart swelled with joy and love for that little home and the people in it who were so willing to express themselves. I still think about that "outrageous" yellow house, and I still love it so.

Imagination allows the impossible, and that is its very strength. It provides a path for the impossible to become possible. So many things that once were thought to be impossible are now not only reality, but mundane. Let's not limit our ocean of creative force by letting it come only through the faucet of acceptable reality.

I have observed over twenty-five years of teaching that the very trait that is the most troublesome obstacle in a student's work is always the student's greatest strength, in disguise. This part of the person is so muscled up, it tends to take over whenever the painter doesn't know what to do next. Students think they have to get rid of that trait, whatever it is, to stamp it out, somehow. Instead, they need to love it. Indeed, it's the part that is most natural to them and is undoubtedly the key to their unique vision.

In the book *The Tao of Pooh* by Benjamin Hoff, Tigger bounces, and sometimes his bouncing is annoying to others, so he thinks he needs to stop being that way. But Tiggers are supposed to bounce. And one fine day, at just the right time, Tigger's bounciness comes in very handy and the day is saved. When I see a student being hard on herself because her natural strength as an artist looks to her right now as just a big stupid habit, I always whisper, "Tiggers are supposed to bounce."

Harry Dayton
HALLOWEEN
Watercolor on paper,
15 × 22" (38 × 56 cm), 1996.
Collection of the artist.

I have been here before,
but when or how
I cannot tell.
Dante Gabriel Rossetti

The Art of the Figure

Toward Creativity

A third way to be in touch with Heart Mind is a form of intuition that I call vibrational sensing. It comes to those whose processing mode is more kinesthetic than verbal or visual.

Are you a person who processes by working out? Running? Dancing? Playing drums? Roller blading? You're probably a person whose vibrational shifts—the actual feeling of your energy moving in your body—will bring you an answer, a decision, or a choice through physical activity, and you feel it in a certain part of your body. Sometimes, you'll just know what you want, without knowing how you know. In the Hindu language of energy centers, chakras as they are called, you are feeling the energy of the third eye, which is said to be located between the brows.

Completing our triad, now we add to "What do I know?" (relating to the universe through landscape art) and "What do I love?" (relating to intimate environs through still life) the question "What do I want?" and find its answer in figure art, which represents our relationship to humankind and how we see ourselves.

Figure art is work that uses humanlike shapes to carry its theme. It can include forms ranging from very realistic portraits to strictly symbolic, purely abstracted figures. Figure art allows us to see our whole self, even those parts that may be hidden from public scrutiny.

Moving figures are featured and deftly built into the intriguing narrative scene *Opening Night* (below) by Harry Dalton. This painting illustrates again how Harry loves the shapes of things. As in his work shown earlier (see pages 101 and 102), he describes intricate subjects with very few lines, but still imbues his paintings with a sense of reality, providing enough mystery to invite viewers to take one more look—then another, and still another. Harry's work honors a real and grounded world, yet it exudes a spiritual dimension that is also powerfully present.

Harry Dayton OPENING NIGHT Watercolor on paper, 11 × 15" (28 × 38 cm), 1997. Collection of the artist.

Relationship is a pervading and changing mystery . . . the mystery waits for people wherever they go, whatever extreme they run to.
Eudora Welty

Jeanne Carbonetti
THE ONE MADE TWO
Watercolor on paper,
26 × 19" (66 × 48 cm), 1991.

From joy all beings
have come,
and unto joy
they all return.
The Upanishads

Figure art is powerful because it's so subjective. When we portray a figure, we're really painting two people: the model in front of us and ourself. Landscapes and still lifes can be impersonal; we can enjoy their content while being detached from it. But a figure stands before us like a person on our doorstep. Deep inside, we recognize part of us and respond in ways that affect us more directly.

This power to move people became clear to me a few years ago when many of my figure paintings were on exhibition and I observed unusually strong viewer reaction, both positive and negative, to them. One of my favorite pieces was *Lilies of the Field,* a happy picture of two carefree figures frolicking in a field of lilies. The man who bought the painting told me that when his friends saw it for the first time at a party he hosted, many adored it and expressed profound admiration. But one woman said she *hated* it and actually showed anger looking at it. When the painting's owner reflected upon it later, he realized that this poor woman had no love in her life, that she always seemed bitter and resentful, and the joy in the painting revealed to her what she lacked. For artists, as well, the figures we choose and how we portray them shows us what we long for within ourselves. Understanding this helps us bring final form out of the funnel of our creative experience.

Jeanne Carbonetti
TIME TO AWAKEN
Watercolor on paper,
30 × 22" (76 by 56 cm), 1991.
Collection of Lydia Ouveroff.

*My heart is like
a singing bird.*
Christina Rossetti

The six principles of visual harmony applied earlier to landscape and still life also apply to figure art. Even if the picture is a portrait of a single figure set against a blank background with no setting or props, your first question should still be, "What story does this painting tell?" Then, focus, composition, value, color, and texture all come into play as importantly in describing that person as they would in depicting a lush landscape or overflowing bowl of flowers.

Every figure you do is an image of another aspect of the self that is seeking expression. It always appears with a gift for you if you are quiet enough to see it. Allow yourself time to be with it, again and again, so that you may receive it, just as painter Fran Danforth has received gifts from her unique Muse.

In *Moon Woman* (opposite), Fran takes solace in her moon spirit, a symbol used throughout mythology to represent moving into one's instinctive, inner wisdom rather than relying on the light of Logical Mind. The symbol is echoed in several moon shapes, adding to the power of the image. Here we see the world of unconscious urgings outside the circle of perception, represented by shapes and colors that merge and emerge, all floating, instead of points of perspective that give us real space frames of reference.

Looking at *Leah* (opposite), we see a figure surrounded by the varied textures and hues of all she faces as she seems to awake from slumber. With her back to a reflective pool, she turns to face the world. By the strength of this composition, I know that this reflective experience was an important one for this woman, for it takes up half the painting. I know that when she gets up and goes back to face the world, it will be with newfound power, for she herself embodies the color and light of the landscape, bringing it together in peaceful harmony.

Artist Ann Kellogg approaches figure painting with a strong foundation in rendering anatomy both in pencil and in watercolor. She also has great facility with the broad blocking aspects of composition, bringing paintings to completion easily. Yet she wasn't quite satisfied with her work. Some piece of the jigsaw puzzle of her personal vision was missing. It was the component of abstraction at an important stage in the process that helped her break through to a new dimension in her work. Her ability to pull things together realistically could then aid in her communication, without overpowering it. *R.A.B. and Roos* and *The Young Geologist* (see page 108) are charming illustrations of this point. What story do these figures tell you? To me, with their light, gentle colors and clean lines, they clearly celebrate the spirit of the young figures depicted and of the artist who created them.

Although I painted *Knowing My Way* and *Fruit of Life* (see page 109) several years apart, I see threads of connection between them. Both tell the story of a woman's awakening to her

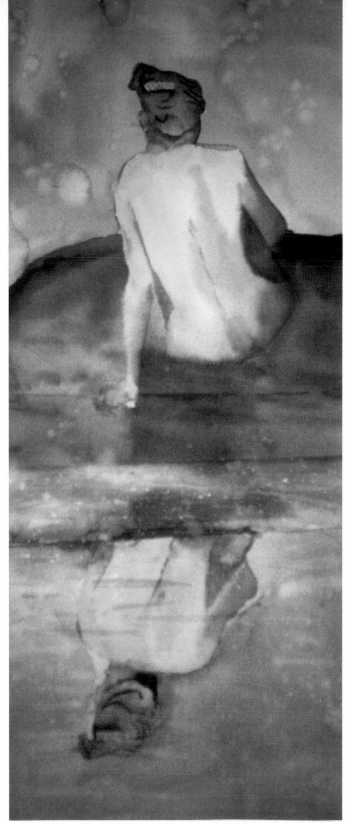

Fran Danforth
Moon Woman
Watercolor on paper, 25 × 22" (64 × 56 cm),
1995. Collection of the artist.

Love is a spirit all compact of fire/Not gross to sink,
but light, and will aspire.

William Shakespeare

Fran Danforth
Leah
Watercolor on paper, 25 × 10" (64 × 25 cm),
1995. Collection of the artist.

Curving back into myself I create again and again.

Vedic Scriptures

own power, the power of her own earthly goodness. The split between spirit and body is being healed in these paintings. In one, a voluptuous Eve opens her eyes to the fruit of life, looking ahead without guilt. In the other, a moment of awareness and decision is declared through the determined movement of the woman's body. In terms of composition, color, and value, the figures merge with their surroundings in such a way that each flows from its background, rather than being separate from it. Even though live models posed for these pictures, the finished products really speak more of interiors, of soul, than of exterior, anatomical renderings.

The same may be said of Zena Robinson's *Garden Spirit at Home* (see page 110). Zena's woman exudes mystique as she sits meditatively, allowing life to move through her. Underwater

Ann Kellogg
R.A.B. and Roos
Watercolor on paper,
14 × 12" (36 × 31 cm), 1996.
Collection of the artist.

*We wove a web
in childhood,
a web of sunny air.*
Charlotte Brontë

Ann Kellogg
The Young Geologist
Watercolor on paper,
12 × 10" (31 × 25 cm), 1996.
Collection of the artist.

*How dear to my heart
are the scenes
of my childhood.*
Samuel Woodworth

life is suggested as the blues and purples spill into each other, causing gentle movement around the figure. There is a connection of landscape form to the figure itself, but purple flower forms emerge and then dissolve above the figure's shoulder. Shapes are clearly formed near her center (the red flower focus), but then dissolve into formlessness at her outer edges. I'm fascinated by the use of red, orange, and yellow at the woman's womb, for in the psychology of color, these are the hues of groundedness, creativity, and consciousness of the first, second, and third energy centers.

Figure art can speak a wonderful affirmation of the strength and beauty of your vision. It's an exciting journey for you to take as you travel along the Zen path of creative painting.

Jeanne Carbonettti
Knowing My Way
Watercolor on paper,
22 × 30" (56 × 76 cm), 1996.
Collection of the artist.

*And yes I said yes
I will Yes.*
James Joyce

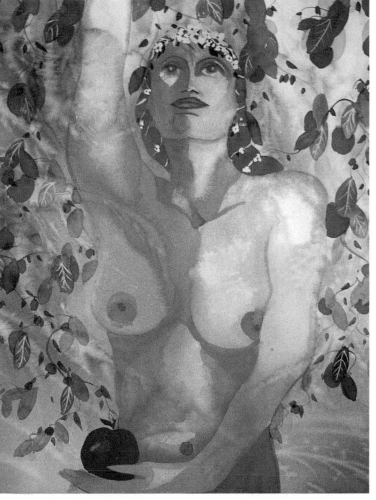

Jeanne Carbonettti
Fruit of Life
Watercolor on paper,
22 × 25" (56 × 64 cm), 1991.
Collection of Deborah Hill.

*Love needs the spirit,
and the spirit love,
for their fulfillment.*
Carl Jung

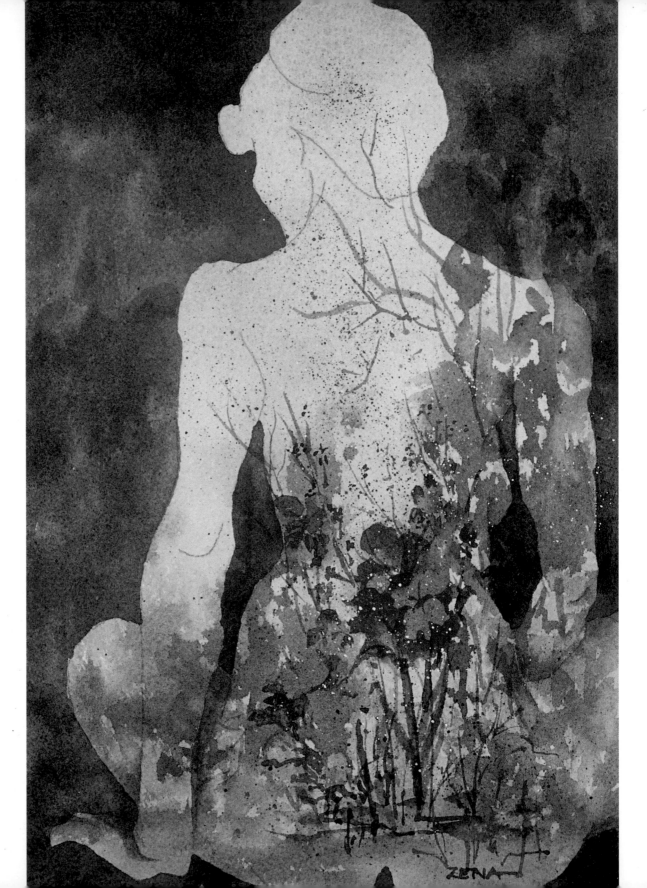

Zena Robinson
GARDEN SPIRIT AT HOME
(INSPIRED BY JOSEPH
SHEPPARD)
Watercolor on paper,
16 × 10" (41 × 26 cm), 1997.
Collection of Carol Emil
Thebarge.

*How do I know
about the world?
By what is within me.*

Lao-tsu

Epilogue: Why Make Art?

With these pages to guide you, I hope you've created at least four pieces of art: a mandala, a landscape, a still life, and figure art. Have you also begun dialoguing with your work through the principles of visual harmony, both in crafting it and later in reading it?

But if you haven't started yet, know that this, too, is a part of the process of creation. If your Muse has been fearful of showing her face, she may present several dirty ones first, just to see how much you love her. It takes time to know yourself as a creator, to find your own special rhythm for work, and time to know your creations and the larger vision that encompasses them. But at least by now, I hope I've persuaded you that creative vision really is your natural birthright; it's part of you. Only when you become fully conscious of how it operates will it be able to flow stronger and unimpeded in you as an artist who can make art that says, "This is me."

I believe it's vitally important for more people to make more art—not just fine artists making their living at it, but everyone, in whatever way they can. Just as we use writing and reading as tools for our Logical Mind, so our ability to express what we see and feel would give us access constantly to the other parts of our being, to our great Body Mind and Heart Mind, helping to keep us whole. Because art is such a pure microcosm of our soul, because it doesn't exist for any other reason than to show us just that, it's a perfect mirror to reflect the sides of ourselves that don't get to dance in public often, but are relegated to the shadows. These are the parts of us that allow us to create. Indeed, art has something to offer everyone no matter what their vocation, not as a means of escape or hobby, but rather as a means of self-knowledge.

By clarifying what you know, what you love, and what you want, you will be free to create. To live this process consciously is to watch a miracle unfold. It is the Zen nature of creativity to meet the Muse face to face. She is revealed as we unfold in wholeness to the Sacred Triangle within, to the beauty, truth, and love of body, mind, and spirit. When we create from unity, we are always original, always powerful. And each time we do, if we listen closely enough, we will hear the voice of creation itself whispering, "Ah, perfect."

Index